General Editor
David Piper

Rembrandt
Every Painting I

Christopher Brown
Deputy Keeper, National Gallery, London

RIZZOLI NEW YORK

Foreword by the General Editor

Several factors have made possible the phenomenal surge of interest in art in the twentieth century: notably the growth of museums, the increase of leisure, the speed and relative ease of modern travel, and not least the extraordinary expansion and refinement of techniques of reproduction of works of art, from the ubiquitous colour postcards, cheap popular books of colour plates, to film and television. A basic need – for the general art public, as for specialized students, academic libraries, the art trade – is for accessible, reliable, comprehensive accounts of the works of the individual great masters of painting; this has not been met since the demise before 1939 of the famous German series, *Klassiker der Kunst*; when such accounts do appear, in the shape of full *catalogues raisonnés*, they are vast in price as in size, and beyond the reach of most individual pockets and the capacity of most private bookshelves.

The aim of the present series is to provide an up-to-date equivalent of the *Klassiker* for the now enormously enlarged public interested in art. Each volume (or volumes, where the quantity of work to be reproduced cannot be contained in a single one) catalogues and illustrates chronologically the complete paintings of the artist concerned. The catalogues reflect as far as possible a consensus of current expert opinion about the status of each picture; in the nature of things, consensus has yet to be reached on many points, and no one professionally involved in the study of art-history would ever be so rash as to claim definitiveness. Within the bounds of human fallibility, however, every effort has been made to achieve both comprehensiveness and factual accuracy, while the quality of reproduction aimed at is the highest possible in this price range, and includes, of course, colour. Every effort has also been made to hold the price down to the lowest possible level, so that these volumes may stay within the reach not only of libraries, but of the individual student and lover of great painting, so that they may gradually accumulate their own 'Museum without Walls'. The introductions, written by acknowledged authorities, summarize the life and works of the artists, while the illustrations place in perspective the complete story of the development of each painter's genius through his career.

David Piper

Introduction

There is an established modern view of Rembrandt's career which divides it into two more or less antipathetic periods – an early, baroque, extrovert period during which the artist had great popular success and a later, lonely, introverted period during which he painted his great spiritual masterpieces. This division, which is artificial and misleading, is all that remains of the romantic nineteenth-century view of Rembrandt as a tragic figure who was isolated from his contemporaries by the uniqueness of his vision. Rejected by Dutch society, he remained true to his inspiration despite great personal hardship.

If, however, we examine the documentary sources for the image of the later, lonely Rembrandt, we find that many of them date from the last quarter of the seventeenth century and are profoundly influenced by the French-derived classicistic criticism which flourished in Holland in the years after Rembrandt's death in 1669. Rembrandt was criticized by these writers not because in the second half of his career he was a forgotten or obscure figure. Had he been, there would have been little point in attacking him. He was criticized for exactly the opposite reason – because he was the most representative artist of his age, its greatest and most characteristic figure, not at all the lonely outcast of legend.

The classicistic critique of Rembrandt's life and work was this: he painted nature as it was rather than as an ideal of beauty; he despised the academies and the rules governing anatomy and perspective, proportion and the imitation of the antique; he was, in the memorable phrase of Andries Pels, 'the foremost heretic in painting'. The Rembrandt personality which critics like Joachim Sandrart and Andries Pels built up from these negative characteristics in the last quarter of the seventeenth century, taking much of their critical language from Italian seventeenth-century condemnations of Caravaggio, was popularized by Arnold Houbraken in his influential *Lives of the Painters*, published between 1718 and 1721.

With the coming of romanticism, this view of Rembrandt as an artist who rejected rules and the classical ideal of beauty and remained true to nature and to his own imagination, made him the object of enormous adulation. Terms of criticism had become terms of praise, and the romantic view has coloured the modern view of Rembrandt.

Trying to reconstruct Rembrandt's own attitude towards his art is difficult, since (with the exception of a contentious phrase in one

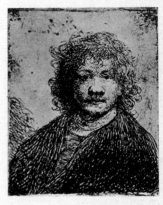

Above: Self-Portrait, 7.1 × 5.9 cm, c.1628; Amsterdam, Rijksprentenkabinet. Below: Rembrandt's signature on The Anatomy Lesson of Dr Nicolaes Tulp *(No. 63)*, The Hague, *Mauritshuis.*

of his seven surviving letters) he did not write about it. The theory of art which had the greatest influence on painting in Holland in the early seventeenth century was that elaborated by Carel van Mander in his *Schilderboek* (Book of Painters) which was published in 1604. Van Mander's age did not entertain the concept of 'subjective expression' in painting. Van Mander stated the painter's aim in life quite bluntly – fame and fortune. He considered the soul of art to be the depiction of the emotions, and there can be no

3

doubt that Rembrandt concurred in this. This view was conceived by van Mander as a general principle and not as a set of rules such as those governing classicism. Rembrandt's emphasis on technique – his concern for the differing textures of the paint itself – is also an element of his adherence to van Mander's concept of art. He surely also shared van Mander's view, which was anathema to the classicists, that a painter could create a beautiful image from an ugly subject.

Rembrandt did not follow a specific and exact theory of art such as the classicists were to develop. Like the rest of his contemporaries, he admired *ingenium* (inborn talent) above any skills a painter might learn. This may be the explanation of the puzzling circles which can be seen painted on to the prepared canvas behind the figure of the artist in Rembrandt's great *Self-Portrait* (2nd vol., No. 395) of about 1666 at Kenwood House, London. The circle on the left is probably an emblem of theory and that on the right one of practice: Rembrandt would therefore have shown himself, with palette and maulstick, as *ingenium*, between theory and practice.

Rembrandt's generation could justify its pragmatic approach to art – as van Mander did – by citing Aristotle, while the younger men, the classicists like Sandrart and Pels whose ideas began to gain general acceptance around 1680, had a greater affinity with Descartes. They were trying to formulate a systematic aesthetic. In van Mander's approach, Idea and Imagination could co-exist easily but in the classicist view Imagination was represented as a threat to Idea and had to be kept firmly under control. Classicism places its reliance on theory at the expense of practical training and of imagination. Of the latter, of course, Rembrandt was the supreme master and for this reason, as well as for his shocking naturalism, the classicist critics attacked him. In choosing to attack him rather than any of his contemporaries, they simply attest to his position as the central figure in the previous generation.

Rembrandt was born in 1606 in Leiden, the son of a miller, Harmen Gerritsz. van Rijn. It was Harmen who had added the designation van Rijn to the family name after the mill which stood on the banks of the Old Rhine. It seems likely that he alone amongst his brothers and sisters was converted from Catholicism to Calvinism. Rembrandt's parents' marriage took place in the Reformed Church in Leiden despite the fact that the bride's parents were from an old Catholic family in the town.

There has always been speculation about the use of members of Rembrandt's family as models in his early paintings. There is only one reliable likeness of Rembrandt's father – in a fine portrait drawing by his son, which is now in Oxford (Ashmolean Museum). It is inscribed with Harmen's name in a seventeenth-century hand. On the basis of this drawing, it is probably correct to say that he was the model for the prophet Jeremiah lamenting the destruction of Jerusalem in the painting of 1629 in the Rijksmuseum (No. 37). Rembrandt's mother may well be the elderly woman whom he painted and etched a number of times early in his career. She is often seen reading the Bible or is represented as an Old Testament prophetess. She seems to have become a devout Calvinist after adopting her husband's faith, and her son was also a Calvinist, if an unconventional one, throughout his life. Rembrandt had close links with the strict Calvinist sect, the Mennonites, though there is no firm evidence that he actually joined them.

Rembrandt's mother's will, and the inventory which was drawn up after her death in 1640 reveal that the family lived in very comfortable circumstances, and Rembrandt certainly enjoyed the best education Leiden could offer. He spent seven years at the Latin school in the town and at the age of fourteen he was enrolled as a student at the university of Leiden. He did not stay long at the university but instead entered the studio of the local painter Jacob Isaacsz. van Swanenburgh who specialized in architectural views and scenes of hell. He had lived in Italy for some years – as had many Dutch artists of his generation – and had a Neapolitan wife.

Rembrandt stayed with Swanenburgh for three years. Some seventeenth-century sources name Joris van Schooten, a local portrait painter, and the more interesting Jacob Pynas of Amsterdam as early teachers of Rembrandt. However, the only painter to make a lasting impression on the young Rembrandt was Pieter Lastman, to whose Amsterdam

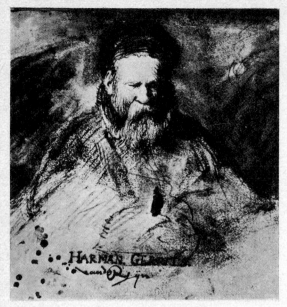

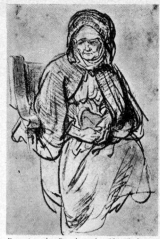

Drawings by Rembrandt of his father (detail: red and black chalk and wash drawing, 18.9 × 24 cm, c. 1630; Oxford, Ashmolean Museum) and of an elderly woman thought to be his mother (red chalk, 24 × 16.2 cm, c.1638; Paris, Louvre).

studio he went for six months in 1624. After his return from Italy in 1610, Lastman soon established himself as the leading history painter (that is, painter of religious, mythological and classical subjects) in Amsterdam. The two principal influences on the development of Lastman's style were Caravaggio (for his dramatic chiaroscuro) and the German painter who lived in Rome, Adam Elsheimer (for the small scale of his work and the elaborate detail of its treatment).

After his short stay with Lastman, Rembrandt returned to Leiden to set up an independent studio. He seems to have shared his studio with Jan Lievens (1607–74), who had also been a pupil of Lastman. The two young artists worked together very closely. They used the same models, and even collaborated on some paintings so that there was confusion in the minds of contemporaries as to which of them had painted certain pictures. The lively exchange of ideas between the two young artists can be seen if we look, for example, at their treatments of the subject of *The Raising of Lazarus*. There is a painting of the subject by Rembrandt now in the Los

Angeles County Museum (No. 36), and a drawing by him dated 1630 in the British Museum. Both owe their basic composition to an etching by Lievens, while Lievens's painting of 1631 (Brighton Museum, Sussex) incorporates compositional ideas from Rembrandt's treatments. Finally, the latest and by far the most successful of all is Rembrandt's etching of c.1632. This majestic and dramatic image, while referring to all the other compositions, is the summation of them and exceeds them all in authority and pathos.

It may well have been that Lievens, although a year younger than Rembrandt, was the more successful of the two young artists during these years, for it was Lievens who first attracted the attention of Constantijn Huygens, secretary of the Prince of Orange. Huygens was a humanist in the Renaissance tradition, a gifted author passionately interested in the visual arts. He acted as artistic adviser to the House of Orange. In 1628–9 Huygens wrote a manuscript autobiography, in which he singles out the two young Leiden painters for praise in his section on contemporary developments in history

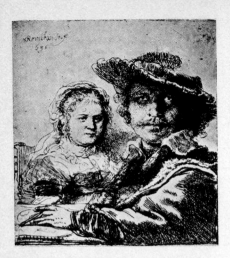

Self-Portrait with Saskia. *Etching, 10.4 × 9.6 cm, 1636; London, British Museum. Rembrandt's and Saskia's attitude is similar to that in* The Prodigal Son *in Dresden (No. 171).*

painting which, following the accepted hierarchy of subjects, he considered to be the highest category of painting. His account is of especial interest as it is the first extensive written reference to Rembrandt: the only earlier mention is by a Utrecht lawyer, Aernout van Buchell, who visited Leiden in 1628 and wrote that Rembrandt 'is highly praised but before time'. Huygens wrote that the miller's son Rembrandt and the embroiderer's son Lievens were already equal to the most famous painters of the day and would soon surpass them. Huygens differentiates between the styles of the two young painters: Rembrandt is superior to Lievens in judgement and in the representation of lively emotional expression. Lievens, on the other hand, has a grandeur of emotion and a boldness which Rembrandt does not achieve.

Huygens predicted a great future for Rembrandt as a painter of historical compositions, adding that although Lievens is an excellent painter he will not easily achieve Rembrandt's skill as a history painter, 'for in historical works, as we commonly term them, no artist, however great and admirable, will easily attain the vivid invention of Rembrandt'.

As a prosperous man and as adviser to the House of Orange, Huygens was in a position to back his own judgement. He had his own portrait painted by Lievens and his brother Maurits's portrait was painted by Rembrandt in 1632 (No. 70) as a pendant to the same artist's portrait of a neighbour and friend of the Huygens family, Jacob de Gheyn III (No. 71).

Constantijn Huygens wrote a poem praising Rembrandt's portrait of his brother. Soon afterwards Rembrandt painted Huygens's brother-in-law Admiral Philips van Dorp (the painting is lost), and it was presumably Huygens who was responsible for the commission given to Rembrandt to paint Amalia van Solms in 1632 (No. 77; Paris, Musée Jacquemart-André). However, by far the most important commission Rembrandt received from the House of Orange was the Passion series which he painted for Frederik Henry during the 1630s. There is no proof that Huygens obtained this commission for Rembrandt; however, Rembrandt's seven letters to Huygens (his only letters to survive), which are all concerned with the commission, confirm that he acted as the artist's agent and record that he was given a picture by Rembrandt in gratitude for his help. The letter of 12 January 1639 contains the much-discussed phrase *die meeste ende die natureelste beweechgelickheyt,* Rembrandt's only comment on his own approach to his art. It seems to mean that he painted the pictures 'with the greatest and most deep-seated emotion', though some prefer the translation 'with the greatest and most natural movement'. The same letter tells us that in gratitude for Huygens's assistance Rembrandt wanted to give him a large painting (10 feet long by 8 feet high). This has been reasonably identified as *The Blinding of Samson* (No. 169; Stadelsches Kunstinstitut, Frankfurt), the most violent picture which Rembrandt ever painted, with a dramatic chiaroscuro which would undoubtedly gain effectiveness from the painter's suggestion that it be hung in a strong light.

Rembrandt must have been very much aware that Huygens and Prince Frederik Henry were great admirers of Rubens. In his autobiography Huygens calls Rubens the 'Apelles of our time'. From the master's work

he selects a head of Medusa (presumably the painting now in the Kunsthistorisches Museum, Vienna) which he says is so terrifying that it is usually covered with a cloth.

There are numerous compositional references in Rembrandt's Passion series to the work of Rubens. In particular, the *Descent from the Cross* (No. 96) is modelled closely on Rubens's great altarpiece of the same subject, which is now in the Cathedral in Antwerp and which Rembrandt knew in an engraving. Rembrandt admired Rubens's work but the Flemish painter's dramatic baroque manner was quite different from Rembrandt's natural artistic language, and his readiness to adopt it in the Passion series is a remarkable instance of his willingness to adapt his style to the known enthusiasms of his patrons. This is not the truculent Rembrandt of legend, never deviating from his own unique vision. His choice of the *Blinding of Samson* as a gift for a man who so admired Rubens's *Medusa* is a further example of this adaptability.

The precise origin of the Passion series commission is not known. Did Huygens see the *Elevation* (No. 95) and the *Descent* (No. 96) in Rembrandt's studio and commission companions? Or were the subjects all chosen? Possibly important in this context is a *Christ on the Cross* (No. 49) of 1631 rediscovered in the early 1960s in a parish church in France.

In or shortly before 1646 Rembrandt was commissioned to add two further canvases to the Passion series: an *Adoration of the Shepherds* (signed and dated 1646), now at Munich (2nd vol., No. 249), which is identical in size and format with the others in the series, and a (now lost) *Circumcision*. The payment of 2,400 guilders which Rembrandt received for these two paintings in November 1646 is the last known contact between Rembrandt and the court circle at The Hague. There can be little doubt that Huygens gradually lost interest in the progress of Rembrandt's career. In June 1631 Rembrandt had taken a 1,000-guilder stake in the art-dealing business of Gerrit van Uylenburch. It seems likely that Uylenburch, a leading Amsterdam dealer, had spotted Rembrandt some time before in Leiden and wanted to sponsor him.

Uylenburch represented many Amsterdam painters. By July 1632 Rembrandt had moved to Amsterdam and was staying in Uylenburch's house on the Sint Anthonisbreestraat. Houbraken, in his life of Rembrandt, describes the move in this way:

Rembrandt was on fire with enthusiasm while he was living in his parents' home, making daily progress in art all by himself. Every now and then he would be visited by connoisseurs; eventually they recommended that he visit a certain gentleman in The Hague to show him and offer him a newly finished painting. Rembrandt carried the painting to The Hague on foot, and sold it for 100 guilders. Bursting with pleasure, and unused to having so much money in his purse, Rembrandt was anxious to get home as quickly as possible, to let his parents share his joy . . . Since he was often called upon to come to Amsterdam to paint portraits and other pictures, he decided, considering that the place particularly appealed to him as a city most favourable to his rise, to move there. This was about 1630.

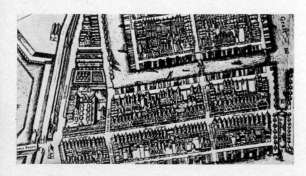

Location (indicated with a circle) of the house in Sint Anthonisbreestraat, Amsterdam, where Rembrandt and Saskia went to live in 1639.

Once arrived in Amsterdam, lodging with Uylenburch, who no doubt made a studio in his house available to him, Rembrandt was deluged with portrait commissions. The picture which must have been a great boost to his reputation was *The Anatomy Lesson of Dr Tulp* (No. 63) painted in 1632. Dr Nicolaes Tulp was a leading Amsterdam surgeon, hailed by his contemporaries as 'the Amsterdam Vesalius' (Vesalius was a Fleming who had revolutionized Renaissance anatomical studies in Padua in the sixteenth century). The Anatomy Theatre in Amsterdam had been built at Tulp's request, and in Rembrandt's painting he is shown demonstrating his anatomical skill in dissecting the muscles of the left arm. Tulp has dissected the brachial musculature and is demonstrating the mechanism of the hand with his own left hand. This is not, however, a public dissection, as has often been thought, since those always began with the abdominal cavity. It seems most likely that the painting does not record an actual event but was commissioned to honour the great anatomist. Rembrandt did not paint the dissected arm and hand from life but from an anatomical illustration. To understand Rembrandt's achievement in this painting it is necessary to look at earlier treatments of this type of subject such as *The Anatomy Lesson of Dr van der Meer* by Mierevelt in 1617 (Delft, Oude en Nieuwe Gasthuis). Mierevelt's painting contains a collection of individual portraits stiffly gathered round a corpse, while Rembrandt's painting is more or less a history picture, a group of figures excitedly participating in an event.

Tulp was a member of one of the leading families of Amsterdam and the success of the *Anatomy Lesson* and other portraits from his earliest years in Amsterdam brought many commissions. Houbraken was probably not exaggerating when he wrote that Amsterdammers had to beg Rembrandt to paint their portraits. Rembrandt's output of portraits in the period 1632–6 is enormous, and he can have had precious little time to paint anything else.

After the intense portrait painting of the early and mid-1630s, Rembrandt's production of portraits fell off markedly at the end of the decade and revived in the early 1640s; from then until his last dated portrait of his friend the poet Jeremias de Dekker in 1666 (2nd vol., No. 397), he painted only occasional portraits.

The reason for this pattern of activity in Rembrandt's portrait painting (based, of course, on paintings which have survived) is unclear. It has been suggested that his portrait style became unfashionable with the fickle Amsterdam public. Certainly Backer, Flinck, Bol and other of Rembrandt's own pupils cornered a large part of the Amsterdam portrait painting market in the late 1630s, 1640s and 1650s. Bartholomeus van der Helst's swagger, Flemish-derived style was also enormously popular in these years, as was Thomas de Keyser's miniaturist portrait style. Indeed, Rembrandt's *Portrait of a Fashionable Couple* (No. 99; Boston, Isabella Stewart Gardner Museum) of 1633, in which the sitters are shown full-length and on an unusually small scale, seems to have been a direct response to de Keyser's success. However, it is important to remember that Aert de Gelder, the last of Rembrandt's pupils, adopted the master's style in the 1660s and

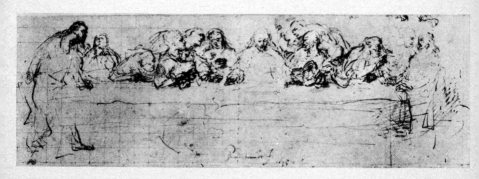

had a successful career working in that style well into the eighteenth century.

More important, therefore, than the question of whether or not Rembrandt remained fashionable was his own increasing reluctance to paint portraits. Rembrandt subscribed to the contemporary hierarchical view of categories of painting which placed history painting at the top and portraiture very low down indeed. Rembrandt had gained his first success as a history painter, and always considered himself a history painter who painted portraits from economic necessity. He simply grew tired of portrait painting in the late 1630s and began to devote himself to history painting again and also to etching, for it is significant that the late 1630s saw a hectic period of etching.

When in the second half of the 1630s Rembrandt returned to history painting, he experimented with great baroque effects, working on a large scale and employing a dramatic chiaroscuro. *The Angel stopping Abraham from sacrificing Isaac* (No. 147; Leningrad, Hermitage) of 1635, the *Samson threatening his father-in-law* (No. 149; Berlin-Dahlem, Gemäldegalerie) also probably of 1635, and *Belshazzar's Feast* (No. 148; London, National Gallery) from the same year were also painted in this style which culminated in the *Blinding of Samson* (No. 169) which Rembrandt gave to Huygens in 1639. If the purpose of art is to astonish and move the spectator, as seventeenth-century theory said that it was, these paintings by Rembrandt certainly fulfilled those criteria. In painting huge and spectacular scenes Rembrandt had the example not only of Rubens in mind. He had also studied the work of those followers of Caravaggio who worked in Utrecht, chief among them Gerrit Honthorst and Hendrick Terbrugghen. These artists had lived in Rome, returning to the Netherlands in the 1620s, bringing with them the naturalistic revolution which had been effected by Caravaggio and his followers. Rembrandt, however, must have come to realize that baroque rhetoric was not his natural language and towards the end of the 1630s this passion for drama and monumentality subsided as he began to evolve his quite individual approach to history painting on a far less heroic scale and with a more painterly treatment of the

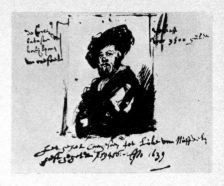

Drawings by Rembrandt: (above) after Raphael's Portrait of Baldassare Castiglione (pen and watercolour, 16.3 × 20.7 cm, 1639; Vienna, Albertina) and (opposite page, bottom) after Leonardo's Last Supper (12.8 × 38.5 cm, 1635; Berlin-Dahlem, Kupferstichkabinett).

narrative. A painting such as *The Risen Christ appearing to Mary Magdalen* (No. 185; London, Royal Collection) of 1638 is an outstanding example of this move towards a more restrained account of Biblical subjects.

In June 1634 Rembrandt had married the cousin of his host in Amsterdam, Saskia van Uylenburch. She was the daughter of a wealthy family from Leeuwarden in Friesland. Her father had served as burgomaster of the town and had been a member of the Friesian High Court. Saskia brought him a large dowry (which created great problems for him after her death) and the marriage certainly represented an improvement in social position for the young successful painter. He seems to have lost touch with his own family, for it was his in-laws rather than his own family who attended christenings in his house, were drawn and painted by him – and eventually quarrelled with him. (In July 1638 Rembrandt's lawyer, his brother-in-law Ulricus Uylenburch, appeared in court at Leeuwarden to bring a libel charge against one of Saskia's relatives who had accused the young couple of squandering Saskia's fortune – which, under certain conditions, was to pass to the relatives. Rembrandt replied that he earned 'richly and *ex superabundanti* (for which he could never thank the Almighty sufficiently)' and had no need of his wife's

money. This was by no means the only occasion on which Rembrandt, an enthusiastic litigant in a litigious age, was represented in court.

Rembrandt painted many portraits of Saskia during the eight years of their marriage, though few follow conventional portrait formulae. In 1635 he painted her as Flora the Roman goddess of spring and flowers (there are two versions, one in the National Gallery, London [No. 152] and the other in the Hermitage, Leningrad [No. 128]). The pastoral mode had become enormously popular in Holland following the great success of *Granida en Daifilo*, a play by the poet P. C. Hooft, which celebrates the joys of country life. He painted his self-portrait as the Prodigal Son with Saskia on his knee (No. 171; Dresden, Gemäldegalerie). The setting is a tavern and the X-rays of the picture show that originally Rembrandt had painted a lute-player in the picture on the left. The setting and the couple's rich clothes make it clear that it is meant to show the Prodigal Son who 'took his journey into a far country, and there wasted his substance with riotous living' (Luke 15:13). Exactly why Rembrandt chose to show himself as the Prodigal Son is unclear, but it may have been a self-mocking confession of the wasteful and extravagant side of his character.

More intimate and far more tender are a number of drawings of Saskia during her numerous pregnancies. Their first child, a boy named Rumbartus, was born in December 1635 but died after two months. Their only child to survive into adulthood was a son, Titus, who was born in 1641.

In January 1639 Rembrandt bought a house in the Sint Anthonisbreestraat, two doors away from that of Hendrick van Uylenburch. The price was 13,000 guilders, of which a quarter was to be paid within a year of taking possession and the remainder 'within five or six years'. Rembrandt never managed to shake off this debt which eventually led to his bankruptcy seventeen years later.

In the National Gallery in London there is a *Self-Portrait* (2nd vol., No. 208) of 1640 which shows Rembrandt at this moment of great success, dressed in furs and wearing a gold chain. The pose is taken from two Italian paintings that Rembrandt had seen in Am-

sterdam shortly before. The portrait of *Baldassare Castiglione*, author of *The Courtier*, by Raphael, which is now in the Louvre, was sold at auction in Amsterdam in April 1639. Rembrandt attended the auction and sketched the picture. It was bought by Alfonso Lopez, a Portuguese dealer living in Amsterdam who also owned Titian's *Portrait of a Man*, then thought to be Ariosto, which is now in the National Gallery, London, and was the other source for Rembrandt's pose in the 1640 *Self-Portrait*.

This borrowing raises the whole question of Rembrandt's study of Italian painting. The traditional view was that Rembrandt broke decisively with the sixteenth-century Netherlandish dependence on Italian types for history painting. After all, he never visited Italy and told Huygens that he was too busy to do so. His independence of Italian painting is real, and the originality of his approach to history painting cannot be over-stressed. However, it has become increasingly clear that Rembrandt carefully studied works of the Italian High Renaissance, and Italian compositional sources can be identified for a considerable number of his works, both paintings and etchings, particularly during the 1640s and 1650s. Indeed, some writers have detected a current of Italian classicism in his work during those decades. The most important Italian influences seem to be Raphael and Titian and the Venetian school, although Rembrandt also made drawings after Leonardo's *Last Supper* and after Mantegna's *Calumny of Apelles*, for example. These would, of course, have been accessible to him in the form of prints.

Rembrandt had studied earlier Northern art and in his etchings in particular he displays a considerable debt to Lucas van Leyden, Hendrick Goltzius and Albrecht Dürer. Recent research has also shown how much Rembrandt owes, particularly in the Biblical paintings of the 1640s and 1650s, to the work of late sixteenth-century mannerist painters both in Flanders and Holland, artists like Marten van Heemskerck of Haarlem and Marten de Vos of Antwerp. He took individual figures or groups of figures from engravings after their often stiff and clumsy representations of Biblical scenes, transforming them almost beyond recognition.

Catalogue of the Paintings

All measurements are in centimetres.
s.d. = signed and dated

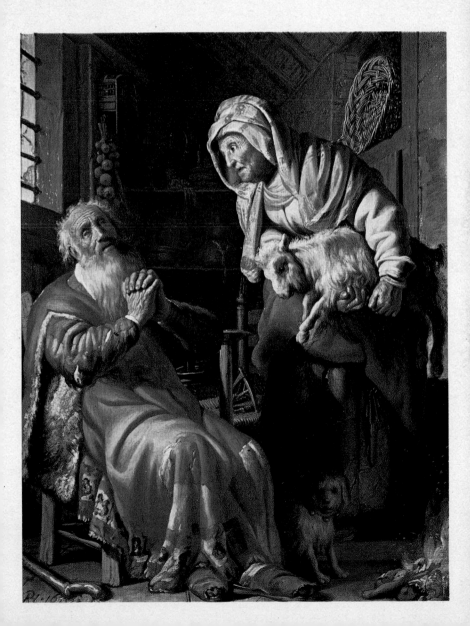

***Anna accused by Tobit of
stealing the kid (No. 4) (p. 11)***
*This picture dates from the
time when Rembrandt was
sharing a studio in Leiden with
the young Jan Lievens. Both
had been pupils of the leading
Amsterdam history painter of
his day, Pieter Lastman. This
painting, the earliest example
of Rembrandt's lifelong
fascination with the story told
in the apocryphal book of
Tobit, displays in its strong,
bright palette, its use of strong
shadow and, above all, in the
linearity of the
draughtsmanship Lastman's
profound influence on the
young Rembrandt.*

1

1 The Stoning of St Stephen
Oil on panel/89.5 × 123.6/
s.d.1625
Lyon, Musée des Beaux-Arts

***2 David presenting the head of
Goliath to Saul***
Oil on panel/27.5 × 39.5/
s.d.162(5?)
Basel, Oeffentliche
Kunstsammlung

***3 Consul Cerialis and the
German Legions (?)***
Oil on panel/89.8 × 121/
s.d.16(26?)
Leiden, Stedelijk Museum
'De Lakenhal'

2

3

***The Supper at Emmaus
(No. 19)***
*Rembrandt has chosen to
portray the highly dramatic
moment in the story of the
Supper at Emmaus when
Christ reveals his identity to
the two apostles. 'And their
eyes were opened, and they
knew him; and he vanished out
of their sight.' (Luke 24:31.)
One of the apostles has pushed
his chair aside and is kneeling
in front of Christ.*

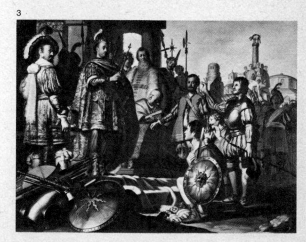

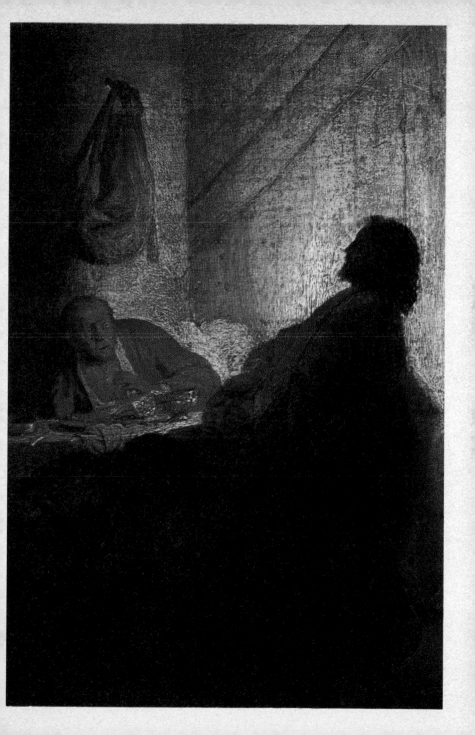

4 Anna accused by Tobit of stealing the kid
Oil on panel/39.5 × 30/
s.d.1626
Amsterdam, Rijksmuseum

5 Christ driving the money-changers from the temple
Oil on panel/43 × 33/s.d.1626
Moscow, Pushkin Museum

6 Balaam's Ass
Oil on panel/65 × 47/s.d.1626
Paris, Musée Cognacq-Jay

7 The Music Party
Oil on panel/63 × 48/s.d.1626
Amsterdam, Rijksmuseum

8 Soldier in a Plumed Hat
Oil on panel/39.6 × 29.3/
c.1626–8
There are doubts about the attribution.
Lugano, Collection of Countess Batthyany

9 An Old Man with a White Beard (the artist's father)
Oil on panel/24.1 × 20.5/
c.1626–8
Formerly Wassenaar, Collection of S. J. van den Bergh

Two Scholars Disputing (No. 20)
This panel of 1628, which shows two scholars who look like Old Testament prophets disputing a theological point, contains many of the most striking features of Rembrandt's history paintings from the Leiden years: the dramatic lighting, brightly lit figures sharply contrasted with figures thrown into deep shadow; expressive gesture and a concern with intricate detail (the books, candle, etc.).

4

5

6

7

8

9

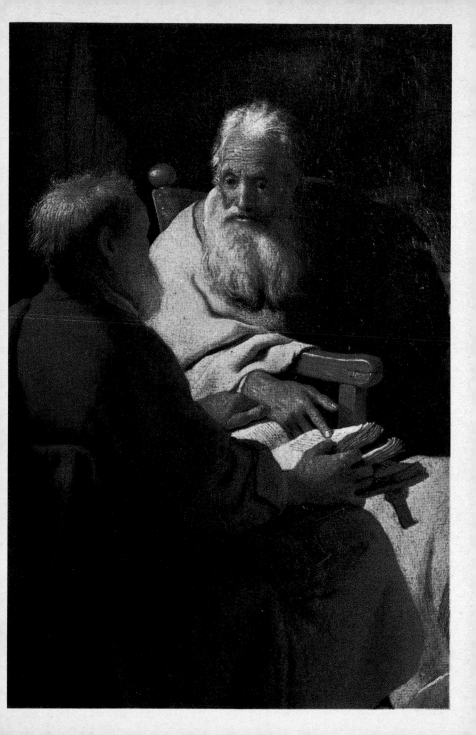

15 A Scholar in a Lofty Room
Oil on panel/55.1 × 46.5/
c.1627–8
Attribution recently doubted.
London, National Gallery

16 The Apostle Peter denying Christ
Oil on copper/21.5 × 16.5/
s.d.1628
Tokyo, Bridgestone Gallery

17 Samson and Delilah
Oil on panel/59.5 × 49.5/
s.d.1628
Berlin-Dahlem,
Gemäldegalerie

18 The Presentation of Christ in the Temple
Oil on panel/55.5 × 44/s./
c.1628
Hamburg, Kunsthalle

19 The Supper at Emmaus
Oil on paper stuck on panel/
39 × 42/s./c.1628–9
Paris, Musée Jacquemart-André

15

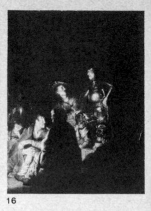

16

17

18

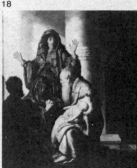

19

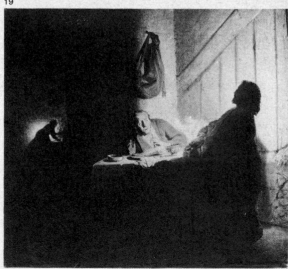

The Prophet Jeremiah lamenting the destruction of Jerusalem (No. 37)
The subject of this painting has been disputed, but it seems likely that the city burning in the distance is Jerusalem which, as Jeremiah had prophesied, was destroyed by Nebuchadnezzar, King of Babylon. Judging from a portrait drawing by Rembrandt which is now in Oxford, the model for the prophet was the artist's father, Harmen Gerritsz. van Rijn.

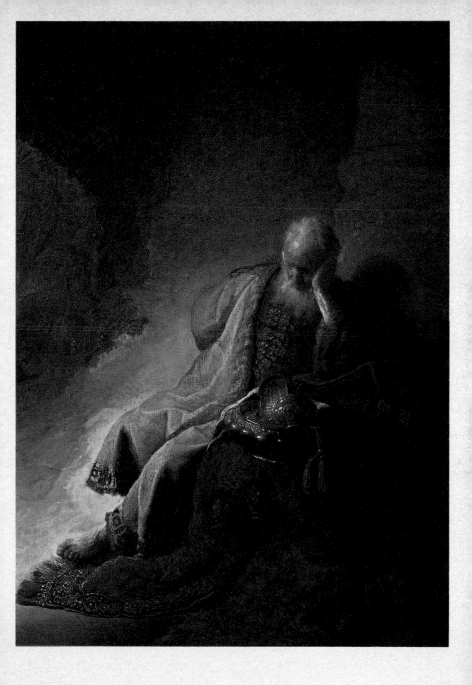

20 Two Scholars Disputing
Oil on panel/72.5 × 60/
s.d.1628
Melbourne, National Gallery
of Victoria

21 An Artist in the Studio
Oil on panel/25 × 31.5/c.1628
Boston, Museum of Fine Arts

**22 The Apostle Paul at his
Desk**
Oil on panel/47 × 39/
c.1628–30
Nuremburg, Germanisches
Nationalmuseum

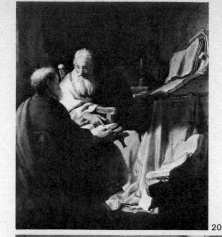

20

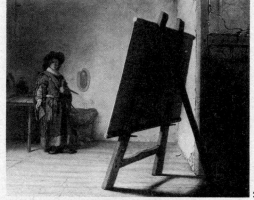

21

The Good Samaritan (No. 38)
This beautiful small panel has
had an interesting critical
history. Accepted by the older
authorities as being an
authentic Rembrandt and the
design upon which the artist
based his etching of 1633 (the
only significant difference is
the inclusion of a dog in the
foreground of the etching), the
picture was gradually dropped
from Rembrandt's generally
accepted oeuvre. Recent
cleaning has revealed the
indisputably autograph quality
of the painting as well as
Rembrandt's Leiden
monogram (RHL) and the
date (1630).

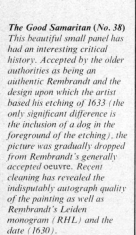

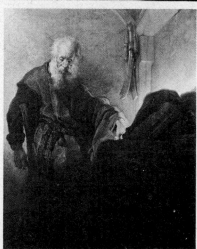

20

22

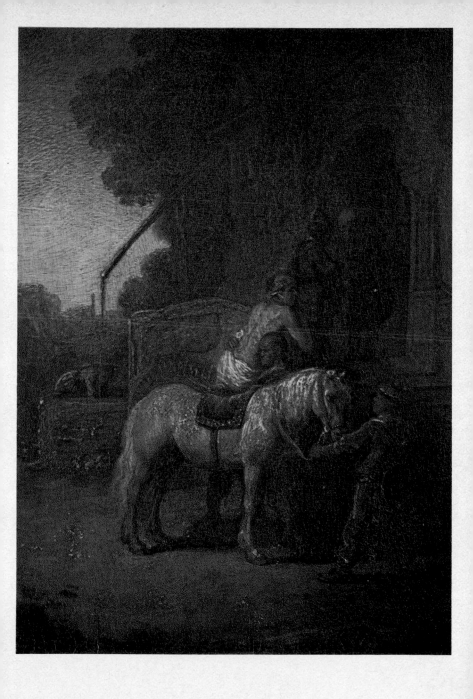

23 The Artist's Mother Praying
Oil on copper/15.5 × 12/
c.1628–9
Salzburg, Czernin Collection

24 An Old Woman (the artist's mother)
Oil on panel/35 × 29/
c.1628–30
Essen, Collection of Mr H. von Bohlen and Halbach

25 Judas and the Thirty Pieces of Silver
Oil on panel/76 × 101/
s.d.1629
Great Britain, Private Collection

26 The Tribute Money
Oil on panel/41 × 33/s.d.1629
Ottawa, National Gallery of Canada

27 David playing the harp before Saul
Oil on panel/62 × 50/c.1629
Frankfurt, Städelsches Kunstinstitut

28 Self-Portrait
Oil on panel/15.5 × 12.7/
s.d.1629
Munich, Alte Pinakothek

23

24

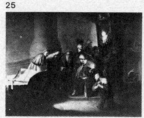
25

26

27

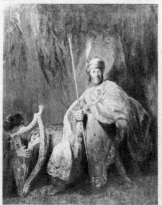

28

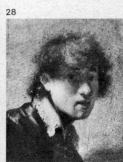

Self-Portrait (No. 39)
Rembrandt used himself as a model when he was experimenting with the representation of facial expression, which he used to such a great extent in his early work to register the reactions of participants and bystanders to dramatic events.

22

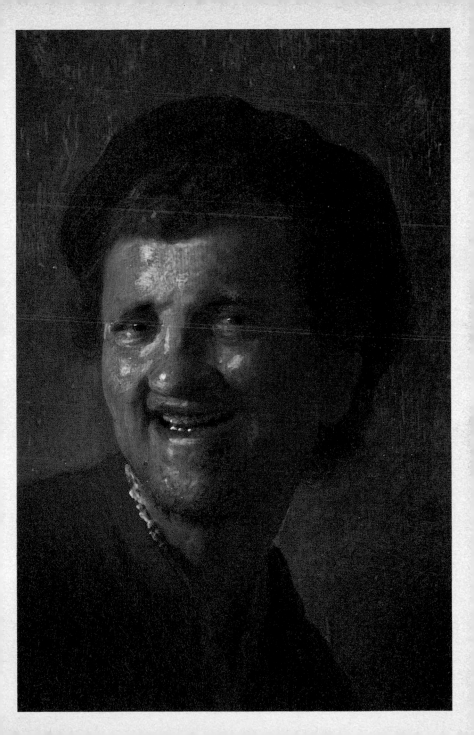

29 Self-Portrait
Oil on panel/89 × 73.5/c.1629
Boston, Isabella Stewart
Gardner Museum

30 Self-Portrait
Oil on panel/37.5 × 29/
c.1629-30
The Hague, Mauritshuis

31 Self-Portrait
Oil on panel/61 × 47/
c.1629-30
Present location unknown

32 Self-Portrait
Oil on panel 72.5 × 58/
c.1629-30
Liverpool, Walker Art
Gallery

33 An Old Woman Reading
(*the artist's mother*)
Oil on canvas/74 × 62/c.1629
Wilton House, Salisbury,
Collection of the Earl of
Pembroke

34 An Old Man in a Cap
Oil on panel/47 × 39/c.1629
The Hague, Mauritshuis

An Old Man in a Fur Hat
(No. 42)
As in the PROPHET JEREMIAH
LAMENTING THE DESTRUCTION
OF JERUSALEM *(No. 37),*
Rembrandt seems to have used
his father as a model in this
painting. He has been dressed
in fancy clothes to represent a
sage or a prophet. With the
strong fall of light on to one
side of the face, throwing the
other side into deep shadow,
Rembrandt is using one of
those devices which made his
portraiture so immediately
successful in the Amsterdam of
the early 1630s.

29

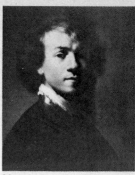
30

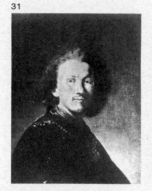
31

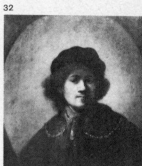
32

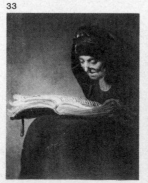
33

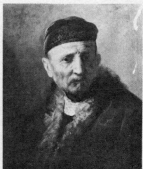
34

24

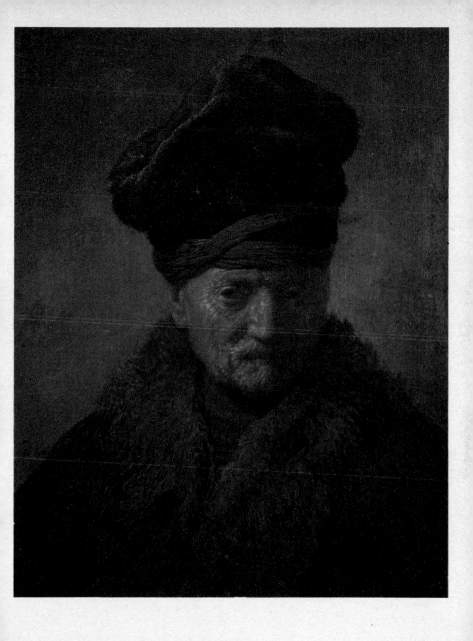

35 An Old Woman (the
artist's mother)
Oil on panel/60 × 45.5/c.1629
Windsor Castle, Royal
Collection

36 The Raising of Lazarus
Oil on panel/93.7 × 81.1/
c.1630
Los Angeles, County
Museum

**37 The Prophet Jeremiah
lamenting the destruction of
Jerusalem**
Oil on panel/58 × 46/s.d.1630
Amsterdam, Rijksmuseum

38 The Good Samaritan
Oil on panel/24.2 × 19.8/
s.d.1630
Recent cleaning has
established the authenticity of
this painting.
London, Wallace Collection

39 Self-Portrait
Oil on panel/41.2 × 33.8/
c.1630
Amsterdam, Rijksmuseum

40 Self-Portrait
Oil on copper/15 × 12/
indistinctly s.d.(1630?)
Stockholm, Nationalmuseum

*The Presentation of Christ
in the Temple (No. 48)*
*'Lord, now lettest thou thy
servant depart in peace,
according to thy word: For
mine eyes have seen thy
salvation.' (Luke 2:29–30.)
Rembrandt chose to represent
the highly dramatic moment of
Simeon's outburst, which
surprises not only the High
Priest, Mary and Joseph,
but also various bystanders
who turn their heads.*

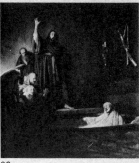

35

36

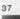

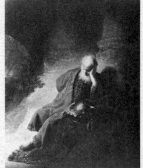

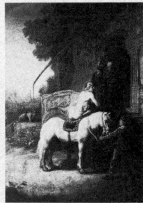

39

40

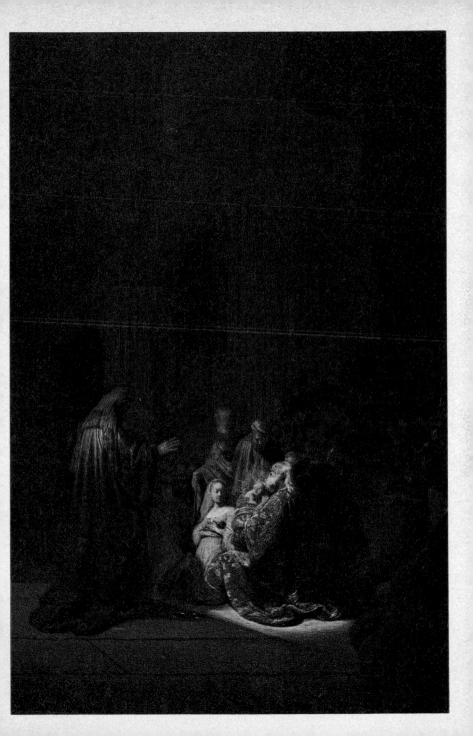

41 Self-Portrait
Oil on panel/49 × 39/s.d.1630
Aerdenhout, Holland,
Collection of J. H. Loudon

42 An Old Man in a Fur Hat
Oil on panel/22 × 17/s.d.1630
Innsbruck, Museum
Ferdinandeum

43 The Repentant St Peter
Oil on panel/75 × 60/c.1630
Boston, Museum of Fine Arts

44 Officer with a Gold Chain
Oil on canvas/82.5 × 74.5/s.
with monogram/c.1630
Chicago, Art Institute

45 An Officer
Oil on panel/64.5 × 51/c.1630
Malibu, California, Getty
Museum

46 Officer with a Gold Chain
Oil on panel/36 × 26/s./c.1630
Leningrad, Hermitage

41

42

43

44

The Prophetess Anna (No. 52)
The prophetess Anna 'was a
widow of about fourscore and
four years, which departed not
from the temple, but served
God with fastings and prayers
night and day.' (Luke 2:37.)
Like Simeon, she recognized
the Child Jesus when he was
brought into the temple by his
parents. There is a tradition,
probably correct, that
Rembrandt used his own
mother, who was a devout
Calvinist, as the model.

45

46

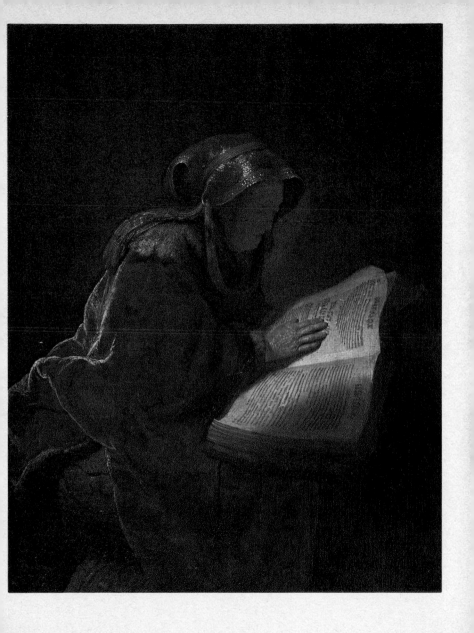

47 An Old Man with a Jewelled Cross
Oil on panel/67.5 × 56/
s.d.1630
Kassel, Gemäldegalerie

48 The Presentation of Christ in the Temple
Oil on panel/61 × 48/s.d.1631
The Hague, Mauritshuis

49 Christ on the Cross
Oil on canvas/100 × 73/
s.d.1631
Although dated 1631, the picture should not be separated from the Passion series (Nos. 95, 96, 170, 194, 195), to which it is closely related in style and subject matter.
Le Mas d'Agenais, France, Parish Church

50 The Apostle Peter in Prison
Oil on panel/58 × 48/s.d.1631
Brussels, Collection of the Prince of Merode-Westerloo

51 A Scholar in a Lofty Room
Oil on panel/60 × 48/s.d.1631
Stockholm, Nationalmuseum

52 The Prophetess Anna
Oil on panel/60 × 48/s.d.1631
Amsterdam, Rijksmuseum

The Rape of Proserpina (No. 60)
Mythological paintings do not form a major part of Rembrandt's work, but he did paint three paintings of stories from Ovid's METAMORPHOSES *around 1632: this painting,* THE RAPE OF EUROPA *(No. 61) and* DIANA AND ACTAEON *(No. 62). The proximity in date and in technique (though the sizes differ) suggest the same patron, who may have been at the Orange Court in The Hague.*

48

47

49

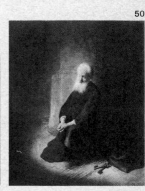
50

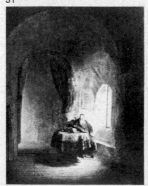
51

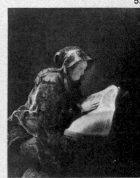
52

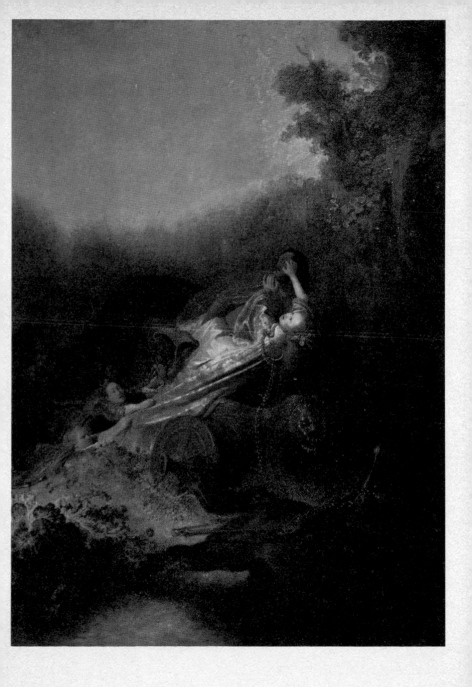

53 An Old Man with a Gold Chain
Oil on panel/60.5 × 51.5/
s.d.1631
Birmingham, City Museum
and Art Gallery

54 A Young Officer
Oil on panel/56 × 45.5/
s.d.1631
San Diego, Fine Arts Gallery

55 Young Man in a Plumed Hat
Oil on panel/80.5 × 66/
s.d.1631
Toledo, Ohio, Museum of
Art

56 Portrait of the Amsterdam Merchant, Nicolaes Ruts
Oil on panel/117 × 87.5/
s.d.1631
New York, Frick Collection

57 Young Man at a Desk
Oil on canvas/113 × 92/
s.d.1631
Leningrad, Hermitage

58 Young Man in a Turban
Oil on panel/65 × 51/s.d.1631
Windsor Castle, Royal
Collection

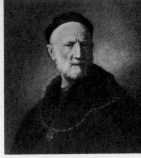

53

54

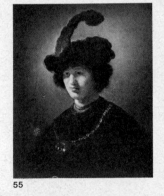

55

56

57

The Anatomy Lesson of Dr Tulp (detail) (No. 63)
The men gathered around Tulp were all friends of his, though only two of them were members of the Amsterdam physicians' guild. The liveliness of their interest in the dissection is in marked contrast to earlier Anatomy Lessons in which the need for accurate portraiture removed any sense of participation. Rembrandt has skilfully combined the two.

32

58

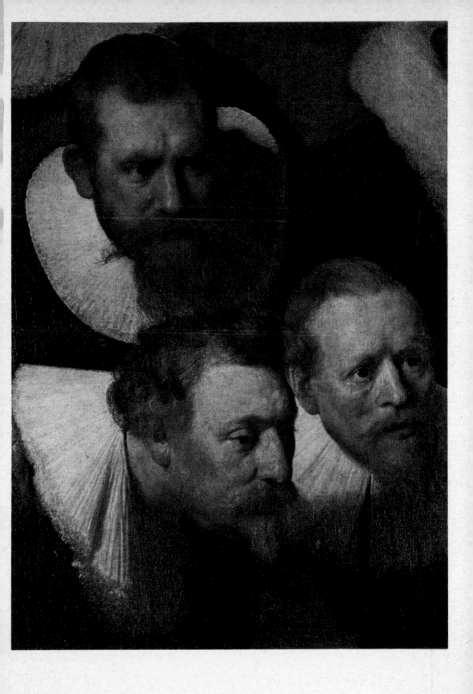

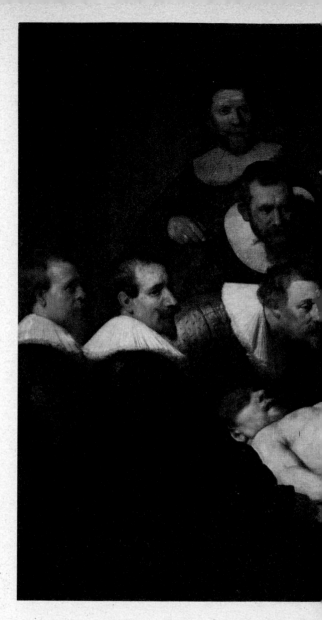

The Anatomy Lesson of Dr Tulp (No. 63)
Dr Nicolaes Pietersz. Tulp (1593–1674) was a leading Amsterdam surgeon, whom his contemporaries hailed as the 'Amsterdam Vesalius'. This painting, in which he is seen dissecting the muscles of the left arm, does not record an actual event but was commissioned to honour the great surgeon. The ANATOMY LESSON *was Rembrandt's first group portrait painted after his arrival in Amsterdam, and must have played an important part in establishing his reputation there.*

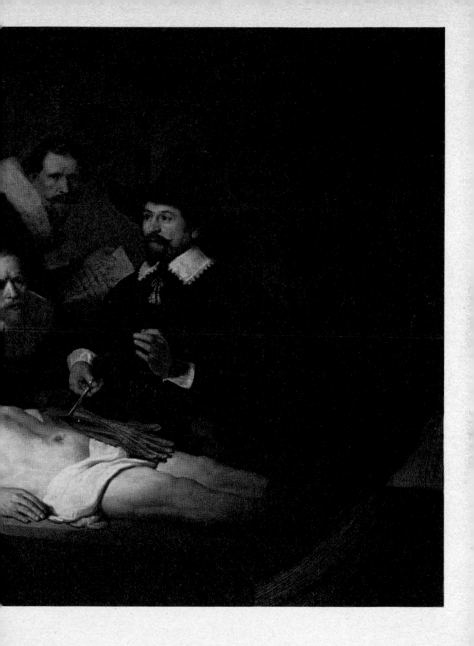

59 Andromeda chained to the rock
Oil on panel/34.5 × 25/*c*.1632
The Hague, Mauritshuis

60 The Rape of Proserpina
Oil on panel/83 × 78/*c*.1632
Berlin-Dahlem,
Gemäldegalerie

61 The Rape of Europa
Oil on panel/61 × 77.5/
s.d.1632
New York, Collection of Mr
Paul Klotz

59

60

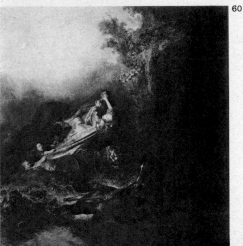

61

The Anatomy Lesson of Dr Tulp (detail) (No. 63)
In this detail Tulp can be seen to have dissected the brachial musculature and is demonstrating the mechanism of the hand with his own left hand. Rembrandt did not paint the dissected hand and arm from life but from an anatomical illustration in Adriaen van den Spiegel's HUMANI CORPORIS FABRICA.

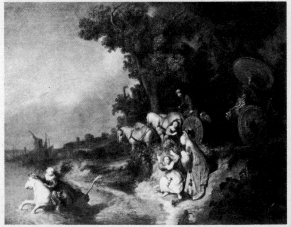

36

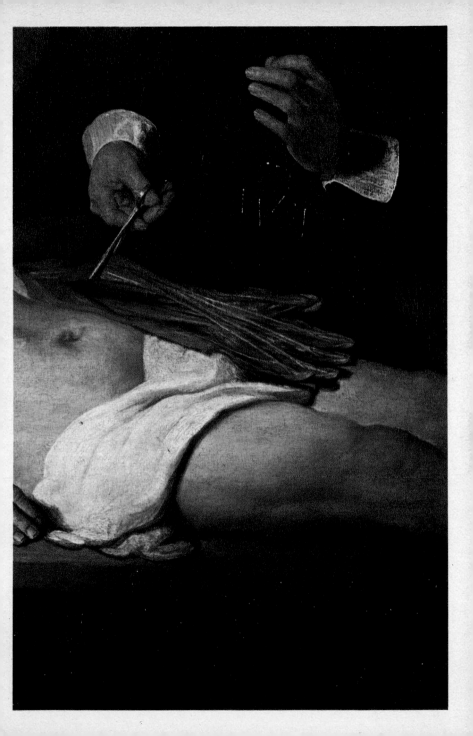

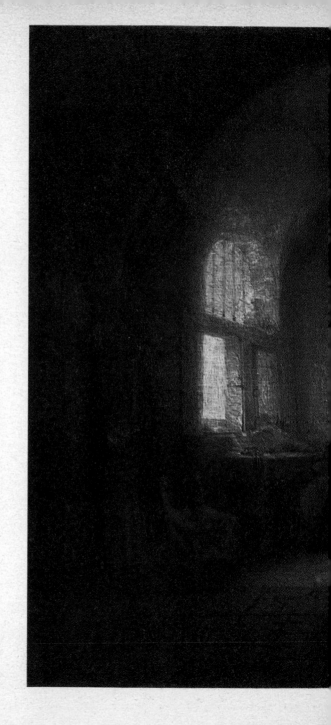

***Scholar in a room with a
winding stair*** (*No. 64*)
*This belongs to a group of
panels, painted in Leiden,
showing scholars at work in
rooms illuminated by a single
strong source of daylight. In
this case the painting presents
a deliberate contrast between
the daylight and the firelight
which illuminate the features
of the scholar and the maid.*

62 The Goddess Diana bathing, with the stories of Actaeon and Callisto
Oil on canvas/73.5 × 93.5/
s.d.163(?)/c.1632–3
Anholt, Germany, Collection of the Prince of Salm-Salm

63 The Anatomy Lesson of Dr Nicolaes Tulp
Oil on canvas/169.5 × 216.5/
s.d.1632
The Hague, Mauritshuis

64 Scholar in a room with a winding stair
Oil on panel/29 × 33/c.1632
Paris, Louvre

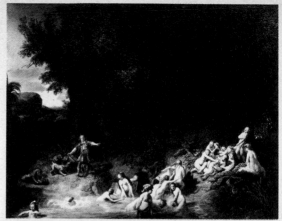

62

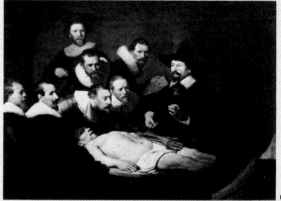

63

Man in Fanciful Costume ('The Noble Slav') (No. 69)
Throughout his career, in addition to conventional portraits, Rembrandt painted character studies. He dressed models in exotic clothes, in this case Oriental robes and a turban, and painted them in portrait format. As in No. 42, Rembrandt has made use of a strong light falling from the left in this large three-quarter-length study.

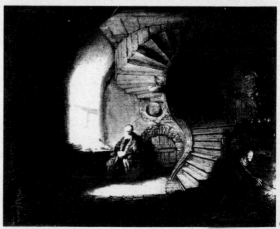

64

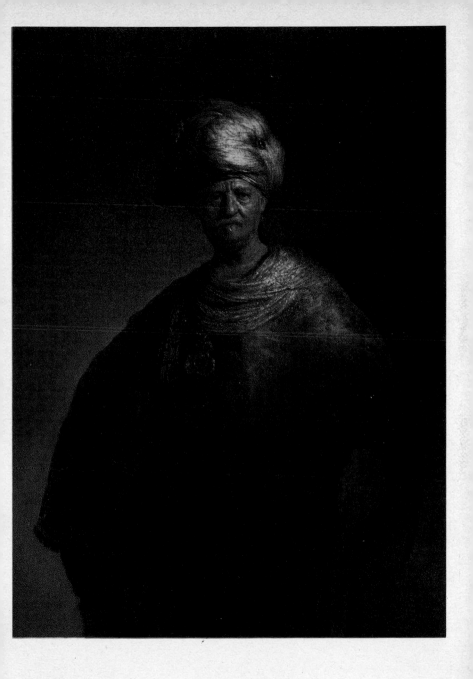

65 Minerva
Oil on panel/59 × 48/*c*.1632
Berlin-Dahlem,
Gemäldegalerie

66 Self-Portrait
Oil on panel/63.5 × 47/
s.d.1632
Glasgow, Burrell Collection

67 Young Man with a Gold Chain
Oil on panel/58 × 44/s.d.1632
Cleveland, Ohio, Museum of Art

68 St John the Baptist
Oil on panel/66 × 48.5/
s.d.1632
Los Angeles, County
Museum of Art

69 Man in Fanciful Costume ('The Noble Slav')
Oil on canvas/152.5 × 112/
s.d.1632
New York, Metropolitan
Museum of Art

70 Maurits Huygens, Secretary of State to the Council of Holland
Oil on panel/31.2 × 24.6/
s.d.1632
Hamburg, Kunsthalle

Amalia van Solms (No. 77)
When this painting was cleaned in 1965, it was revealed to have a decorative painted frame similar to that around a portrait of Prince Frederik Henry of Orange by Gerrit van Honthorst (Huis ten Bosch, The Hague). That portrait is also in profile, and is dated 1631. This commission to paint a pendant to the Honthorst seems to have been Rembrandt's first from the Orange Court.

65

66

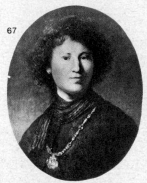
67

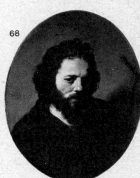
68

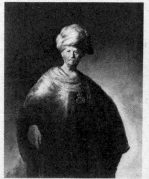
69

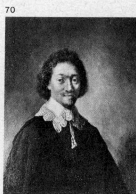
70

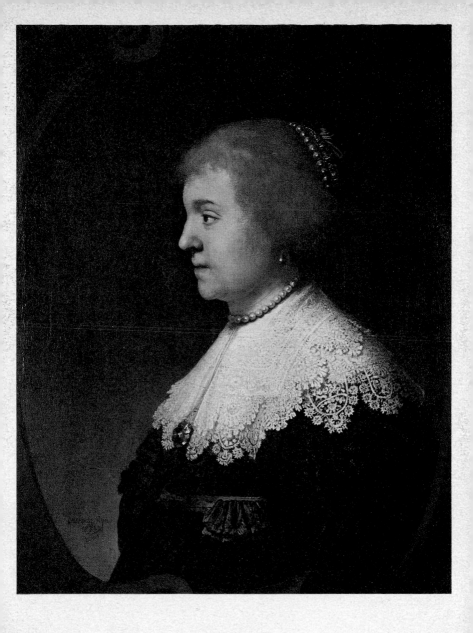

71 Jacob de Gheyn III
Oil on panel/30 × 25/s.d.1632
London, Dulwich College
Gallery

72 Old Man with a Bald Head
Oil on panel/50 × 40.5/
s.d.1632
Kassel, Gemäldegalerie

**73 Young Man in a Broad
Collar**
Oil on panel/63 × 46/s.d.1632
Wanas, Sweden, Collection of
Count Wachtmeister

**74 Bearded Old Man with a
Gold Chain**
Oil on panel/59.3 × 49.3/
s.d.1632
Kassel, Gemäldegalerie

75 Marten Looten
Oil on panel/91.5 × 75/
s.d.1632
Los Angeles, County
Museum of Art

**76 Young Man sharpening a
quill**
Oil on canvas/101.5 × 81.5/s./
c.1632
Kassel, Gemäldegalerie

**Descent from the Cross
(No. 96)**
*This painting is one of a series
representing scenes from the
Passion which Rembrandt
painted for the Prince of
Orange in the 1630s. In this
case the composition is based
on the altarpiece of the same
subject by Rubens in the
Cathedral in Antwerp.
Rembrandt, who knew that
painting in the form of an
engraving, was well aware of
the enormous admiration
which Rubens's work
commanded at the Orange
court.*

71

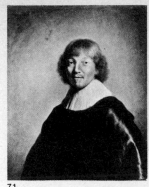

72

73

74

75

76

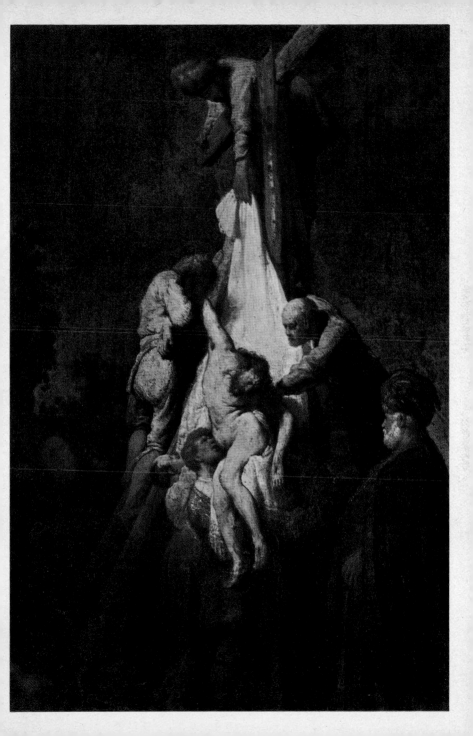

77 Amalia van Solms
Oil on canvas/68.5 × 55.5/
s.d.1632
Paris, Musée Jacquemart-
André

**78 Young Woman in a Pearl-
trimmed Beret**
Oil on canvas/68.5 × 53.5/
s.d.1632
Zürich, Collection of Dr A.
Wiederkehr

**79 Young Woman with an
Embroidered Robe**
Oil on panel/58 × 43/s.d.1632
Boston, Museum of Fine Arts
(on loan from Mrs Richard
C. Paine)

**80 Young Woman with a
Golden Necklace**
Oil on panel/64 × 49/s.d.1632
Allentown, Pennsylvania, Art
Museum (Kress Collection)

**81 Young Woman with an
Embroidered Robe**
Oil on panel/55 × 48/s.d.1632
Milan, Brera

82 Young Woman with a Fan
Oil on canvas/72 × 54/
s.d.1632
Stockholm, Nationalmuseum

**Portrait of a Fashionable
Couple (No. 99)**
*In this double portrait
Rembrandt was responding to
an established taste in
Amsterdam for meticulous
detail (note, for example, the
exquisite detail of the woman's
stomacher) as seen in the
portraits of artists like
Nicolaes Eliasz. and Thomas
de Keyser. X-rays of the
painting show that Rembrandt
first included a small boy
brandishing a stick (perhaps
whipping a top) between the
parents.*

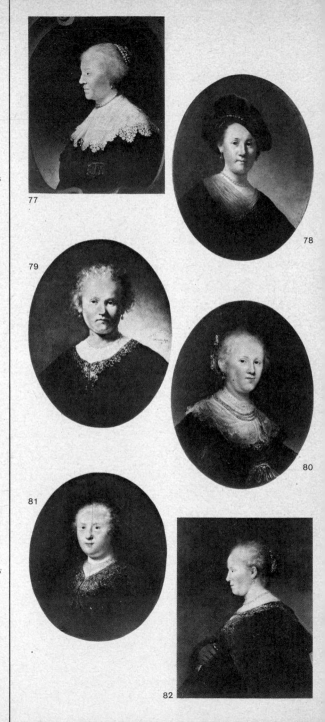

77

78

79

80

81

82

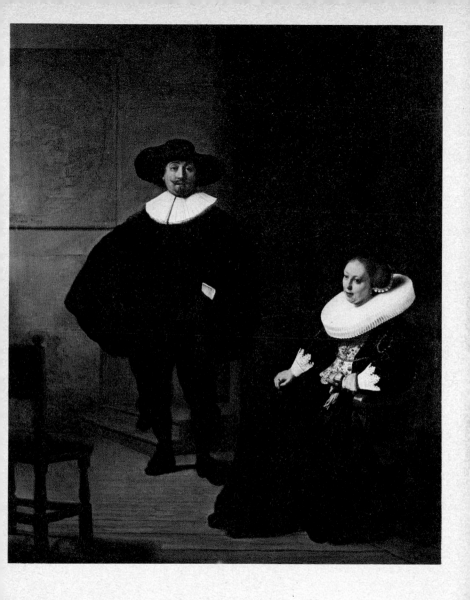

89 Cornelia Pronck, wife of Aelbert Cuyper
Oil on panel/60 × 47/s.d.1632
Pendant to No. 88.
Paris, Louvre

90 Old Woman in a White Cap
Oil on panel/75 × 55.5/
s.d.1632
Paris, Private Collection

91 Portrait of a Young Woman
Oil on canvas/92 × 71/
s.d.1632
Vienna, Akademie der bildenden Künste

92 Esther preparing to intercede with Ahasuerus
Oil on panel/109 × 94/
s.d.163(3?)
Ottawa, National Gallery of Canada

93 Daniel and Cyrus before the idol of Bel
Oil on panel/22.5 × 28.7/
s.d.1633
Great Britain, Private Collection

Saskia (detail) (No. 103)
This portrait of Saskia, like No. 101, dates from 1633. There is in Berlin a SELF PORTRAIT of Rembrandt which in size, pose, dress (Rembrandt wears the same hat as Saskia) and mood suggest that it was a pendant. The pair of portraits may well have been painted to celebrate the couple's engagement.

The Shipbuilder and his Wife (No. 107) (pp. 52–3)
Rembrandt made a number of exciting experiments with the double portrait formula. In this case the conventional side-by-side arrangement has been abandoned in favour of a moment of 'arrested motion' in which the wife rushes into the room with a message for her husband, whose drawings for a ship can be clearly seen.

89

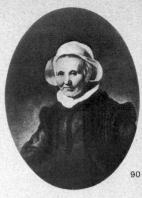
90

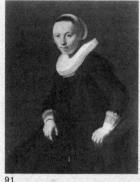
91

92

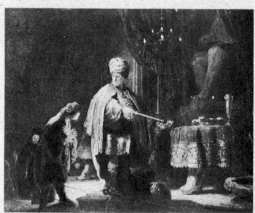
93

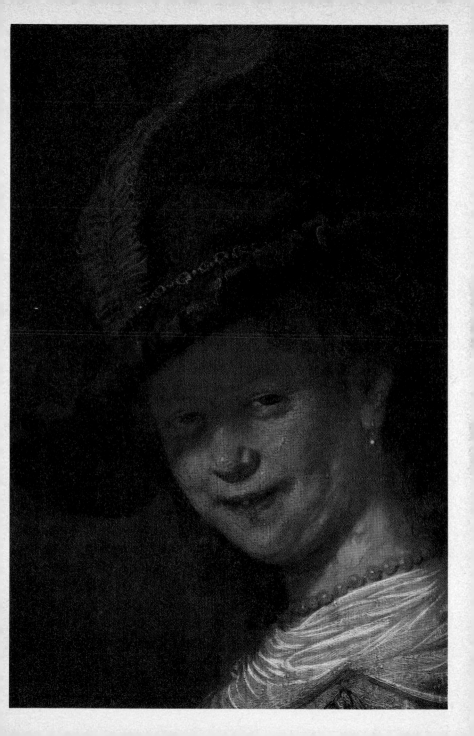

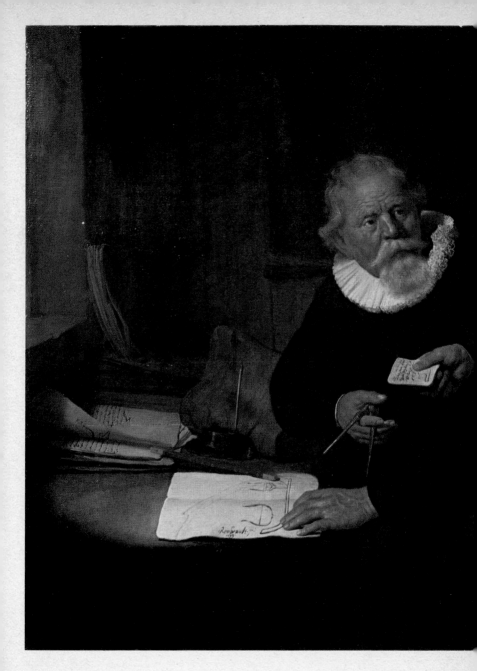

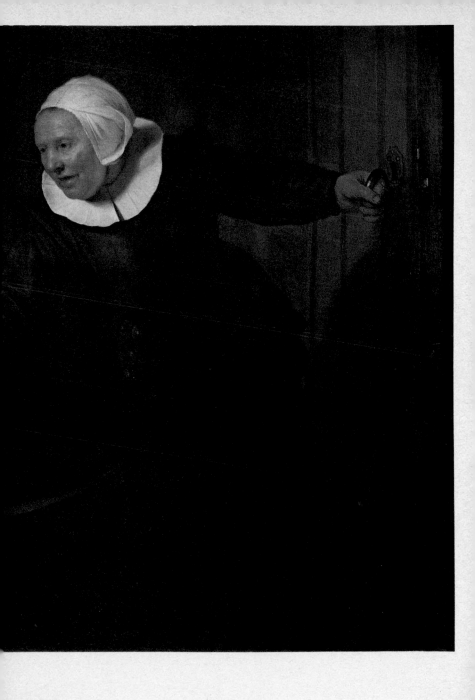

94 Christ in the Storm on the Sea of Galilee
Oil on canvas/160 × 127/
s.d.1633
Boston, Isabella Stewart
Gardner Museum

95 The Elevation of the Cross
Oil on canvas/96.2 × 72.2/
c.1633
Munich, Alte Pinakothek

96 The Descent from the Cross
Oil on panel/89.4 × 65.2/
c.1633
Munich, Alte Pinakothek

97 Portrait of a Woman
Oil on panel/68 × 50/s.d.1633
Said by some authorities to
be a pendant to No. 86 but
far inferior in quality. The
attribution to Rembrandt has
been doubted.
New York, Metropolitan
Museum of Art

98 Self-Portrait
Oil on panel/58 × 45/s.d.1633
Paris, Louvre

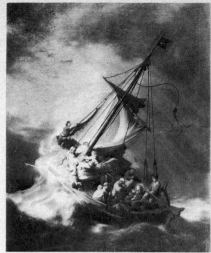
94

Self-Portrait (No. 111)
*Painted in the early years of
his success in Amsterdam
(1633–4), this self-portrait
shows the artist presenting a
more sophisticated face to the
world than in the comparable
'military' SELF-PORTRAIT of
the Leiden years (No. 30).
The technical devices,
however, are the same: the fall
of light across the face and the
illumination of the wall behind.*

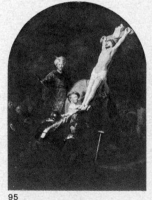
95

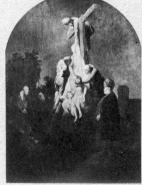
96

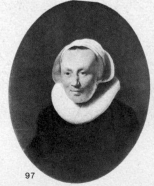
97

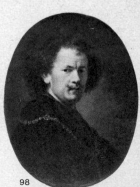
98

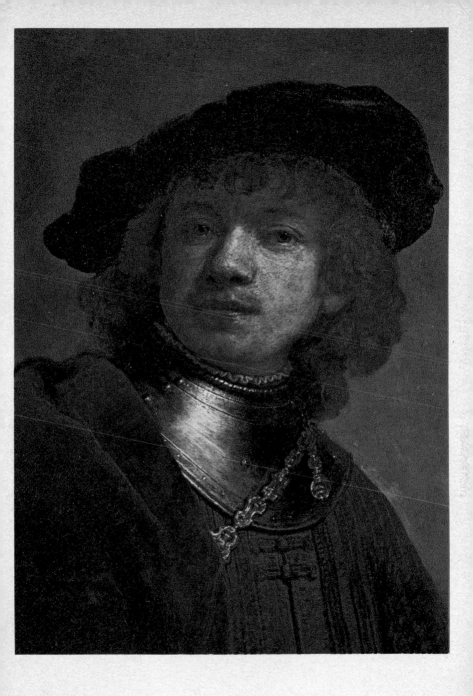

99 Portrait of a Fashionable Couple
Oil on canvas/131 × 107/
s.d.1633
Boston, Isabella Stewart
Gardner Museum

100 A Richly Dressed Young Boy
Oil on panel/67 × 47.5/c.1633
Leningrad, Hermitage

101 Saskia with a Veil
Oil on panel/66.5 × 49.7/
s.d.1633
Amsterdam, Rijksmuseum

102 Self-Portrait
Oil on panel/55 × 46/c.1633
Perhaps a pendant to
No. 103.
Berlin-Dahlem,
Gemäldegalerie

103 Saskia
Oil on panel/52.5 × 44.5/
s.d.1633
Perhaps a pendant to
No. 102.
Dresden, Gemäldegalerie

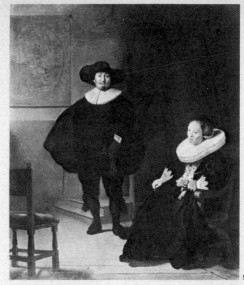
99

100 101

102 103

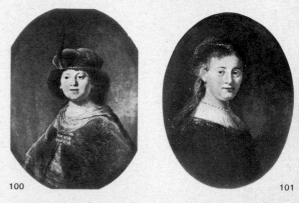

Man in an Oriental Costume (detail) (No. 118)
Even during the years of his most hectic activity as a portrait painter, Rembrandt continued to paint studies of this kind, dressing models in exotic robes and posing them in commanding attitudes. This detail shows a fascinating contrast between the intricacy of the painting of the robe and its fastening, and the economy with which Rembrandt has sketched the features of the hand.

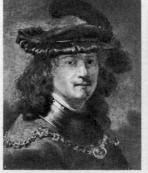

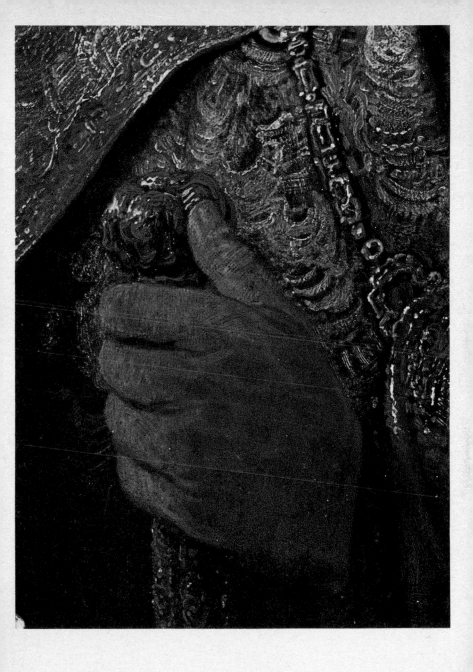

104 Old Man
Oil on panel/9.5 × 6.5/
s.d.1633
New York, Collection of Mr
Arthur A. Houghton Jnr

**105 The Preacher Johannes
Uyttenbogaert**
Oil on canvas/132 × 102/
s.d.1633
Dalmeny, Scotland,
Collection of the Earl of
Rosebery

**106 The Poet Jan Hermansz
Krul**
Oil on canvas/128.5 × 100.5/
s.d.1633
Kassel, Gemäldegalerie

**107 The Shipbuilder and his
Wife**
Oil on canvas/114.5 × 169/
s.d.1633
London, Buckingham Palace,
Royal Collection

108 Man rising from a chair
Oil on canvas/124.5 × 99.5/
s.d.1633
Perhaps a pendant to
No. 109.
Cincinnati, Taft Museum

**Sophonisba receiving the
poisoned cup (detail) (No.
125)**
*The subject of Sophonisba is
rare in Dutch art, and it was
presumably specifically
commissioned from
Rembrandt. She was the wife
of Syphax, King of Numidia,
who was defeated by the army
of Scipio led by the exiled
Numidian prince, Masinissa.
Masinissa would have married
her to prevent her going to
Rome as a captive but Scipio
forbade it. Rather than be
paraded before the Roman
populace, she took poison and
died.*

104

105

106

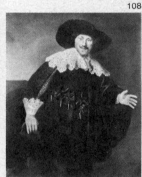

108

107

58

109 Young Woman with a Fan
Oil on canvas/126 × 101/
s.d.1633
Perhaps a pendant to
No. 108.
New York, Metropolitan
Museum of Art

110 Young Woman with a Gold Chain
Oil on canvas/62 × 55.5/
s.d.1633
South America, Private
Collection

111 Self-Portrait
Oil on panel/67 × 54/c.1633–4
Florence, Uffizi

112 Richly Dressed Child
Oil on panel/44 × 33/s.d.1633
France, Private Collection

113 Woman with a Lace Collar
Oil on panel/63.5 × 48.5/
s.d.1633
Santa Barbara, California,
Collection of Mr C. M.
Converse

114 The Rotterdam Merchant Willem Burchgraeff
Oil on panel/67.5 × 52/
s.d.1633
Pendant to No. 115.
Dresden, Gemäldegalerie

**Belshazzar's Feast (No. 148)
(pp. 62–3)**
*In the second half of the
1630s, Rembrandt painted a
number of large canvases of
scenes from the Bible in a
flamboyant Caravaggesque
style. However he soon
reverted to a small-scale,
narrative treatment of Biblical
subjects. In this case, it is
interesting to note that the
Hebrew inscription was at first
incorrect (as can be seen in
the X-rays) but was later
altered, no doubt with the help
of Jewish friends of the artist.*

109

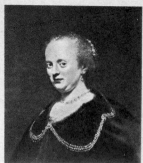

110

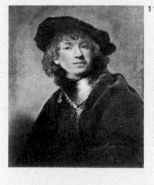

111

112

113

114

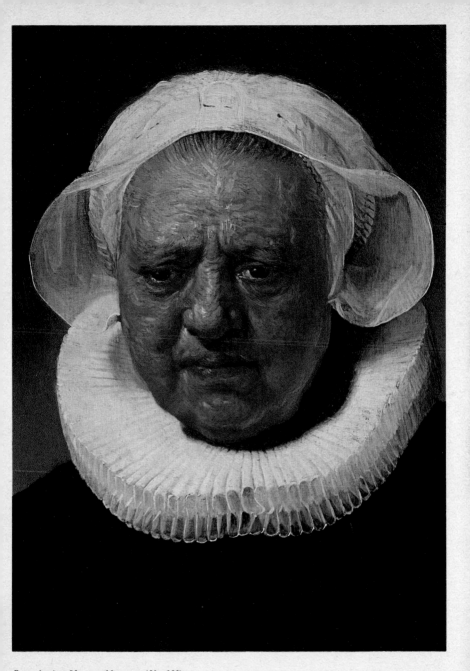

Portrait of an 83-year-old woman (*No. 132*)
Although this must have been a commissioned portrait, it has much of the character of one of Rembrandt's studies. Clearly he must have felt the sitter to be particularly sympathetic, for he lavished especial care on the portrait, carefully describing the intricate contours of wrinkles and veins on her face.

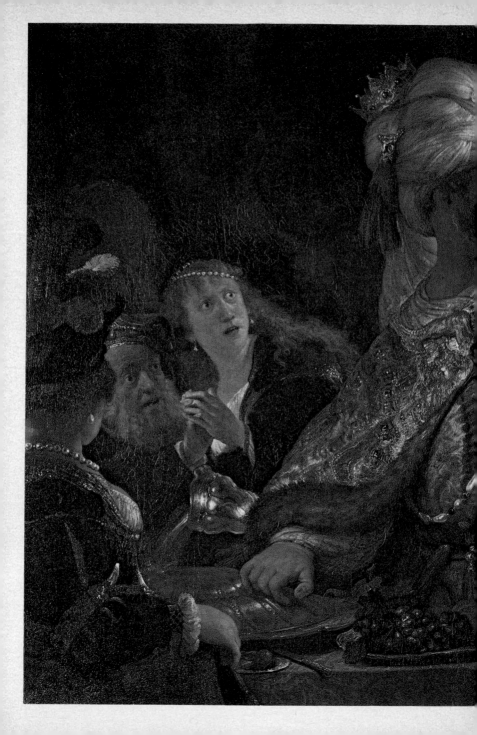

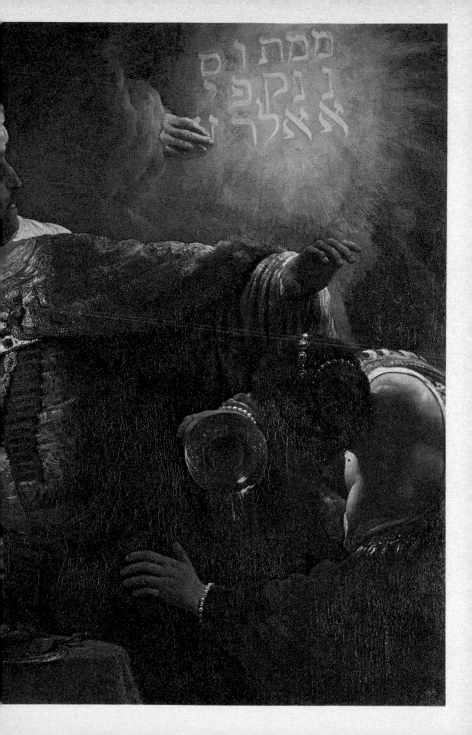

115 Margaretha van Bilderbeecq, wife of Willem Burchgraeff
Oil on panel/67.8 × 55/
s.d.1633
Pendant to No. 114.
Frankfurt, Städelsches Kunstinstitut

116 Bearded Man in a Wide-brimmed Hat
Oil on panel/69.3 × 54.8/
s.d.1633
Pendant to No. 131.
Lugano, Switzerland, Thyssen-Bornemisza Collection

117 Bearded Man with a Flat Broad Collar
Oil on panel/63.5 × 50.5/
s.d.1633
Probably a pendant to No. 121.
Beverly Hills, California, Loew Collection

118 Man in Oriental Costume
Oil on panel/85.8 × 63.8/
s.d.1633
Munich, Alte Pinakothek

119 Portrait of a Seated Man
Oil on panel/90 × 68.7/
c.1633–4
Pendant to No. 120.
Vienna, Kunsthistorisches Museum

120 Portrait of a Seated Woman
Oil on panel/90 × 67.5/
c.1633–4
Pendant to No. 119.
Vienna, Kunsthistorisches Museum

The Holy Family (No. 150)
Painted at the time when Rembrandt was also engaged on the Passion series, the composition of this picture owes a great deal to the artist's study of Rubens as do the other pictures in that series. However, in the lighting, the rich dark palette and the tender regard of Joseph for the Child, Rembrandt has transformed Rubens's baroque design.

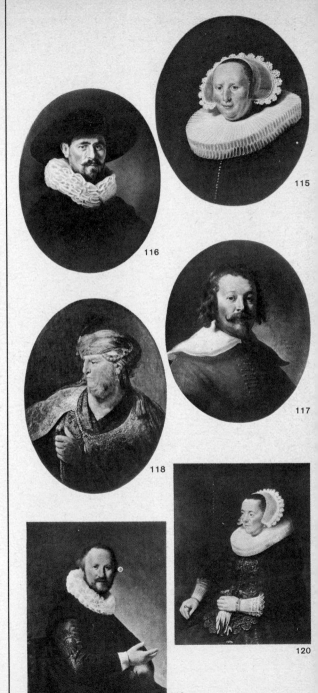

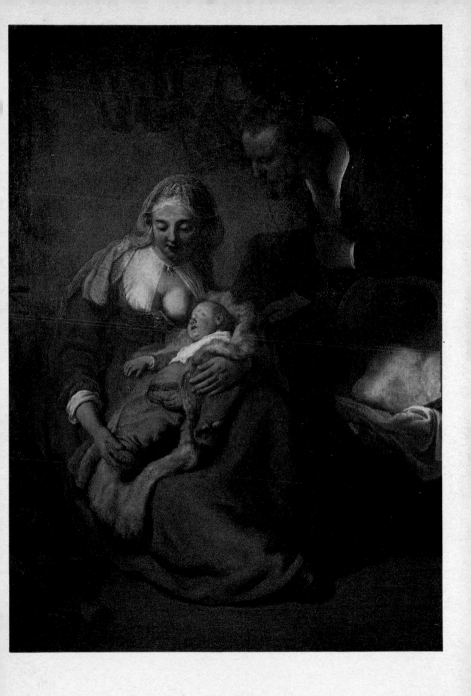

121 Portrait of a Young Woman
Oil on panel/61 × 50/s.d.1633
Probably a pendant to
No. 117.
New York, Private Collection

122 The Descent from the Cross
Oil on canvas/158 × 117/
s.d.1634
Leningrad, Hermitage

123 The Risen Christ showing his wound to the Apostle Thomas
Oil on panel/53 × 51/s.d.1634
Moscow, Pushkin Museum

124 The Flight into Egypt
Oil on panel/52 × 41/
s.d.163(4?)
London, Collection of Lord Wharton

121

122

124

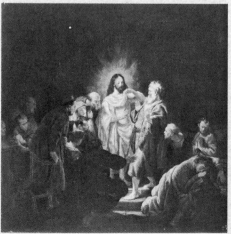

Saskia as Flora (No. 152)
In this portrait, Rembrandt painted his wife as Flora, the Roman goddess of flowers and the spring. The pastoral mode was enjoying a vogue in Holland at the time, in part as a result of the success of a play by the poet P. C. Hooft, GRANIDA EN DAIFILO. *It became fashionable to be portrayed as a shepherd or shepherdess or to be represented in idealized pastoral dress.*

123

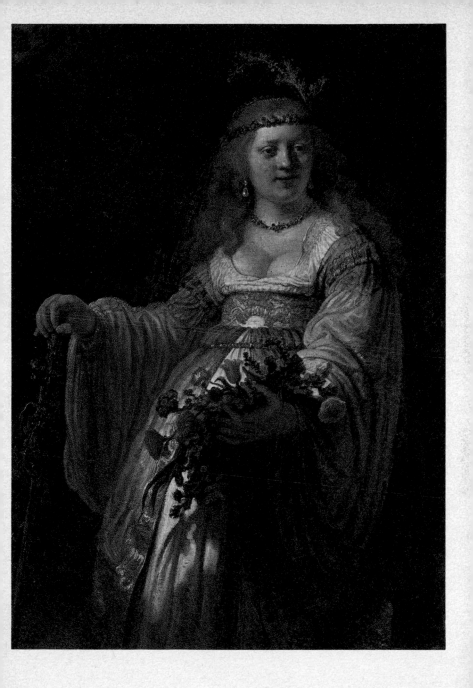

125 Sophonisba receiving the poisoned cup
Oil on canvas/142 × 153/
s.d.1634
Madrid, The Prado

126 The Preaching of St John the Baptist
Grisaille – oil on canvas laid
down on panel/62 × 80/*c*.1634
Berlin-Dahlem,
Gemäldegalerie

127 Christ before Pilate and the People
Grisaille – oil on paper stuck on
canvas/54.5 × 44.5/s.d.1634
London, National Gallery

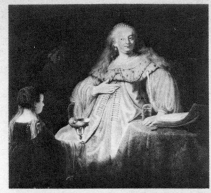

125

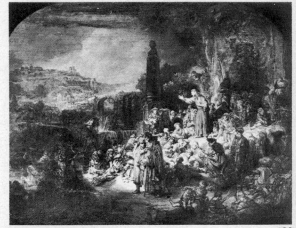

126

Man in Oriental Costume
(No. 153)
*Another character study, this
time from 1635. A head of this
kind (a* tronje *in Dutch) was
probably painted with the idea
of using it in a large Biblical
composition such as the*
BELSHAZZAR'S FEAST, *though
few artists painted such heads
with as much care and concern
for intricate detail as
Rembrandt.*

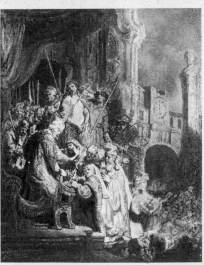

127

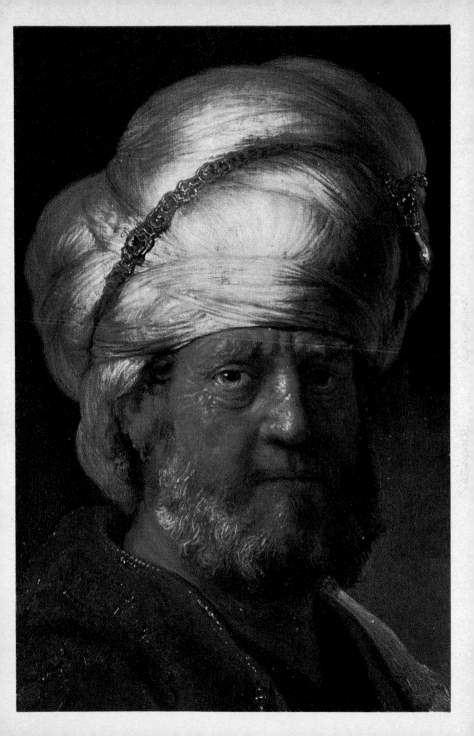

128 Saskia as Flora
Oil on canvas/125 × 101/
s.d.1634
Leningrad, Hermitage

129 A Scholar in his Study
Oil on canvas/141 × 135/
s.d.1634
Prague, Národní Galerie

130 Self-Portrait
Oil on panel/68 × 53/
s.d.163(4?)
Paris, Louvre

131 Portrait of a Young Woman
Oil on panel/66.2 × 52.5/
s.d.1634
Pendant to No. 116.
London, Private Collection

132 Portrait of an 83-year-old Woman
Oil on panel/68.5 × 54/
s.d.1634
London, National Gallery

133 Self-Portrait
Oil on panel/80.5 × 66/
s.d.1634
Kassel, Gemäldegalerie

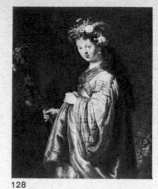

128

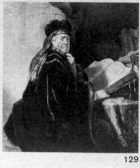

129

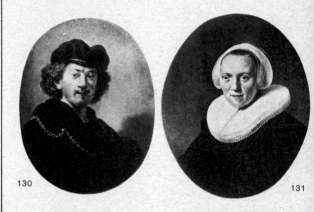

130

131

Portrait of Susanna van Collen with her daughter, Eva Susanna (No. 159)
This superb full-length portrait has a pendant (also in the Wallace Collection) which shows Susanna's husband Jan Pellicorne and their son Caspar. The portraits are illustrative of the wise management of money, for Jan is handing his son a pouch containing money and Susanna gives her daughter a single coin. Boys must learn to care for fortunes and girls for the small sums involved in housekeeping.

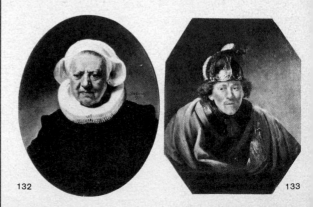

132

133

70

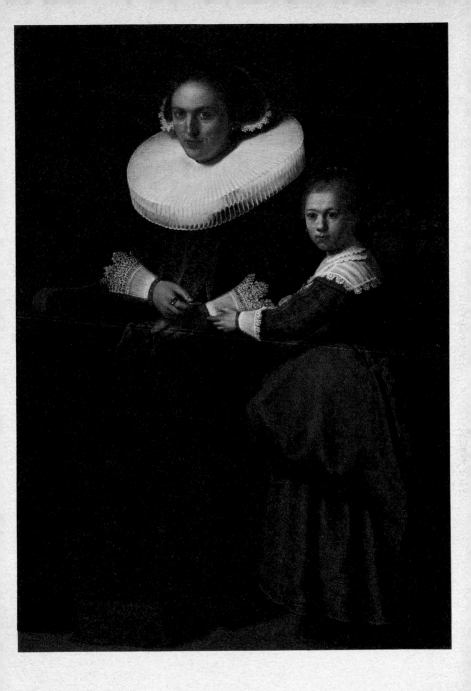

The Blinding of Samson by the Philistines (No. 169)
This is without doubt the most violent picture that Rembrandt ever painted. It was painted for Constantijn Huygens, who was artistic adviser to the Prince of Orange. It was he who had secured the commission for the Passion series for Rembrandt, and the artist gave him this painting to thank him. In the letter which accompanied the picture, Rembrandt advised that it be hung in a strong light in order to have the greatest effect.

134 Self-Portrait
Oil on panel/57 × 46/s.d.1634
Berlin-Dahlem,
Gemäldegalerie

135 Bearded Man in a Wide-brimmed Hat
Oil on panel/70 × 52/s.d.1634
Pendant to No. 136.
Boston, Museum of Fine Arts

136 Young Woman with a Gold Chain
Oil on panel/70 × 52.5/
s.d.1634
Pendant to No. 135.
Boston, Museum of Fine Arts

137 Boy with Long Hair
Oil on panel/47 × 37/s.d.1634
Welbeck Abbey, Collection of
the Duke of Portland

138 The Preacher Johannes Elison
Oil on canvas/173 × 124/
s.d.1634
Pendant to No. 139.
Boston, Museum of Fine Arts

139 Maria Bockenolle, wife of Johannes Elison
Oil on canvas/174.5 × 124/
s.d.1634
Pendant to No. 138.
Boston, Museum of Fine Arts

Self-Portrait with Saskia (No. 171)
Rembrandt painted this self-portrait with Saskia a year or so after their marriage in June 1634. The setting and the couple's rich dress make it clear that the painting tells the story of the Prodigal Son who 'took his journey into a far country, and there wasted his substance with riotous living' (Luke 15:13). Why Rembrandt should show himself as the Prodigal Son is unclear: perhaps it is a confession of the extravagant side of his own nature.

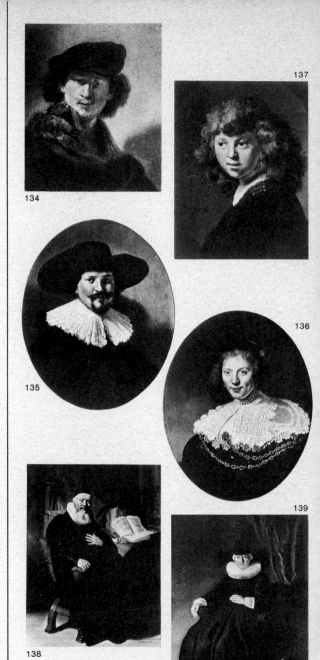

134

137

135

136

138

139

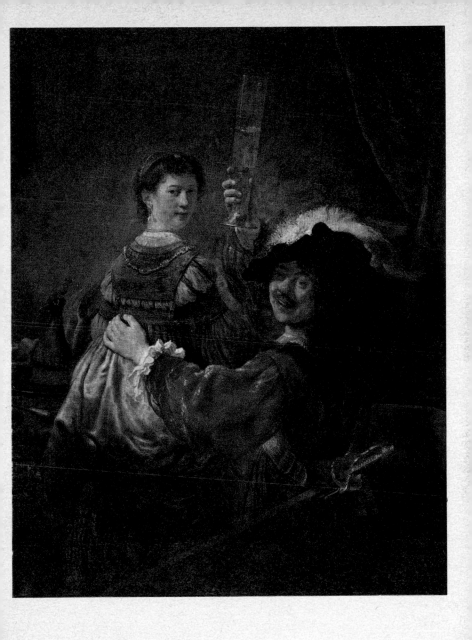

140 Marten Soolmans
Oil on canvas/210 × 135/
s.d.1634
Pendant to No. 141.
Paris, Private Collection

**141 Oopjen Coppit, wife of
Marten Soolmans**
Oil on canvas/209.4 × 134.3/
s.d.1634
Pendant to No. 140.
Paris, Private Collection

**142 Young Man with a
Moustache**
Oil on panel/70 × 52/s.d.1634
Pendant to No. 143.
Leningrad, Hermitage

**143 Young Woman with
Flowers in her Hair**
Oil on panel/71 × 53.5/
s.d.1634
Pendant to No. 142.
Edinburgh, National Gallery
of Scotland (on loan from the
Duke of Sutherland)

144 Man of the Raman Family
Oil on panel/67 × 52/s.d.1634
Pendant to No. 174.
Wassenaar, Holland,
Collection of Mr H. Kohn

**145 King Uzziah stricken with
leprosy**
Oil on panel/101.5 × 77/
s.d.1635
Chatsworth, Derbyshire,
Devonshire Collection

**Stormy Landscape with an
Arched Bridge (No. 178)
(pp. 78–9)**
*This extensive landscape with
its high viewpoint shows how
firmly Rembrandt, in his
painted but not his drawn and
etched landscapes, adhered to
a traditional Netherlandish
landscape formula. The near-
monochrome tonality, with the
recession conveyed by
striations of greens and
browns, displays the profound
influence that the landscapist
Hercules Seghers had on the
evolution of Rembrandt's
landscape style.*

140

141

142

143

144

145

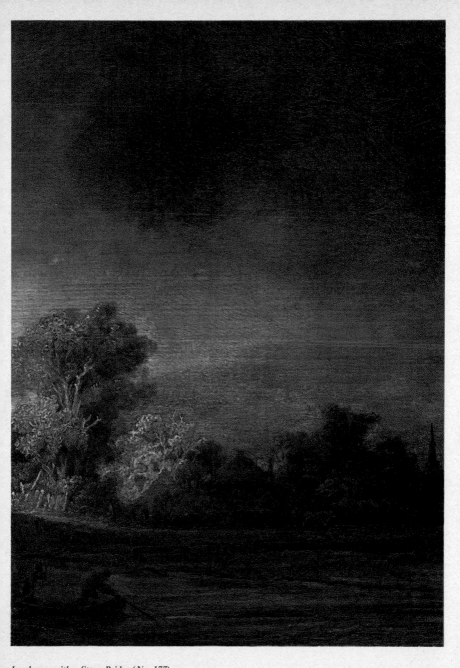

Landscape with a Stone Bridge (*No. 177*)
Rembrandt painted few landscapes and none of them, with the exception of the WINTER LANDSCAPE (Kassel, Gemäldegalerie) of 1646, had the immediacy and freshness of his landscape etchings and drawings. Rather they belong to a Netherlandish tradition of mannerist landscape painting.

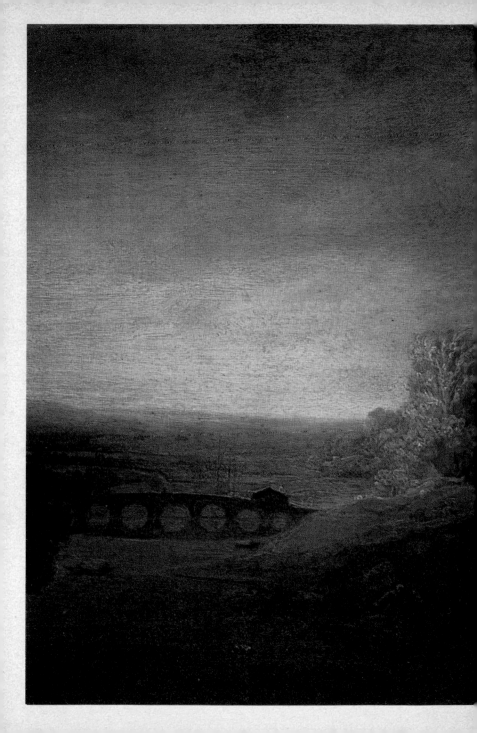

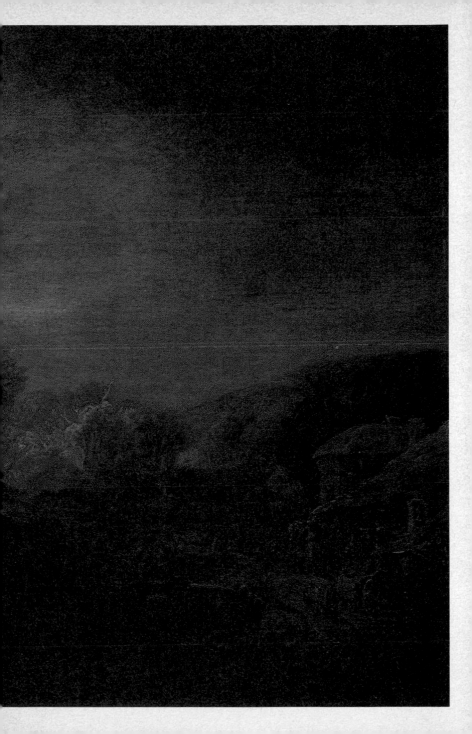

146 The Abduction of Ganymede
Oil on canvas/171 × 130/
s.d.1635
Dresden, Gemäldegalerie

147 The Angel stopping Abraham from sacrificing Isaac
Oil on canvas/193 × 133/
s.d.1635
Leningrad, Hermitage

148 Belshazzar's Feast
Oil on canvas/167.5 × 209/
s.d.163(5?)
London, National Gallery

149 Samson threatening his father-in-law
Oil on canvas/156 × 129/
s.d.163(5?)
Cut down on the left.
Berlin-Dahlem, Gemäldegalerie

150 The Holy Family
Oil on canvas/183.5 × 123/
s.d.163(?)/c.1635
Munich, Alte Pinakothek

146

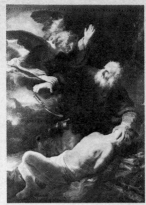

147

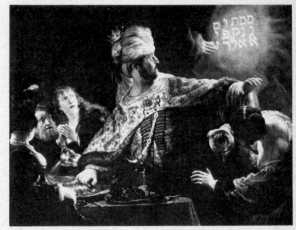

148

150

149

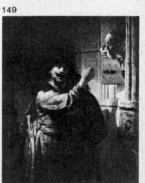

Susannah and the Elders (No. 181)
This Old Testament subject has traditionally given artists a welcome opportunity to paint the female nude. Rembrandt has exploited the chance to the full, no doubt posing a model as Susannah. She is here painted naturalistically as a frightened young girl, whose innate modesty is offended by the presence of the leering elders.

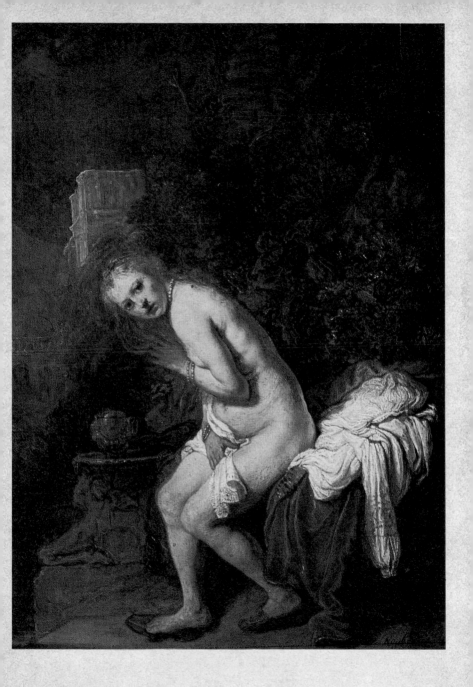

151 Minerva
Oil on canvas/137 × 116/
s.d.1635
London, Collection of Julius
Weitzner

152 Saskia as Flora
Oil on canvas/123.5 × 97.5/
s.d.1635
London, National Gallery

153 Man in Oriental Costume
Oil on panel/72 × 54.5/
s.d.1635
Amsterdam, Rijksmuseum

154 Self-Portrait
Oil on panel/92 × 72/s.d.1635
Formerly Vaduz, Collection
of the Prince of Liechtenstein

**155 Man with Dishevelled
Hair**
Oil on panel/66.5 × 52.5/
s.d.1635
New York, Acquavella
Galleries

156 Saskia
Oil on panel/59 × 45.5/c.1635
Washington DC, National
Gallery of Art

157 Saskia
Oil on panel/99.5 × 78.8/
c.1635
Kassel, Gemäldegalerie

151

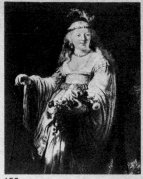
152

154

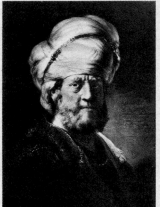
153

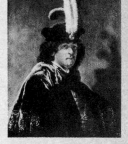
155

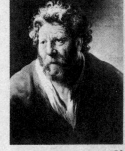
156

**A Man in Polish Costume
(No. 183)**
*Another character study, but
in this case in place of
Oriental robes the elderly
model wears the clothes of a
wealthy Pole. They may well
be studio props, of the kind
which Baldinucci tells us
Rembrandt bought at auction:
'At auction he acquired clothes
that were old-fashioned and
disused as long as they struck
him as bizarre and
picturesque . . .'*

157

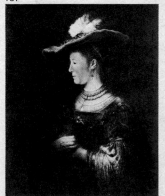

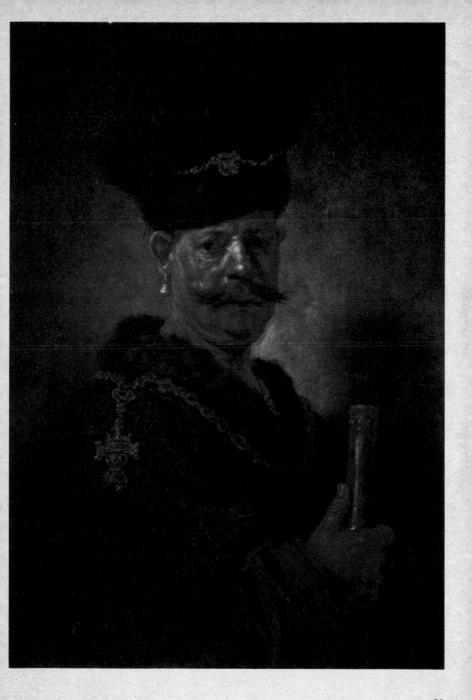

158 Jan Pellicorne and his son, Caspar
Oil on canvas/155 × 122.5/s./
c.1635
Pendant to No. 159.
London, Wallace Collection

159 Susanna van Collen, wife of Jan Pellicorne and her daughter, Eva Susanna
Oil on canvas/155 × 123/
s.d.16(..)/c.1635
Pendant to No. 158.
London, Wallace Collection

160 Philips Lucasz, Councillor of the Dutch East India Company
Oil on panel/79.5 × 59/
s.d.1635
Pendant to No. 161.
London, National Gallery

161 Petronella Buys, wife of Philips Lucasz
Oil on panel/76 × 60/s.d.1635
Pendant to No. 160.
New York, Collection of Mr André Meyer

162 Man in a Wide-brimmed Hat
Oil on canvas transferred to panel/76 × 65/s.d.1635
Pendant to No. 163.
Indianapolis, Collection of Mr Earl C. Townsend, Jnr

163 Portrait of a Young Woman
Oil on panel/77.5 × 66/
s.d.1635
Pendant to No. 162.
Cleveland, Museum of Art

Child with Dead Peacocks (detail) (No. 189)
This painting is a great rarity in Rembrandt's work, as it is the only painting in which the real subject is a still-life of birds. In an age when Dutch painters tended to specialize in landscape, genre painting, portraiture, still-life and so on Rembrandt, though in the first place a history painter, tried his hand at all these types of painting.

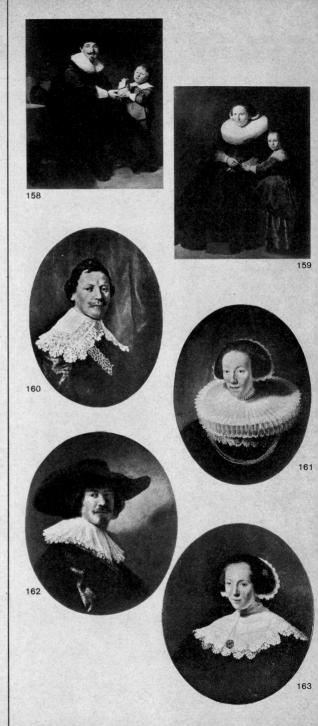

158

159

160

161

162

163

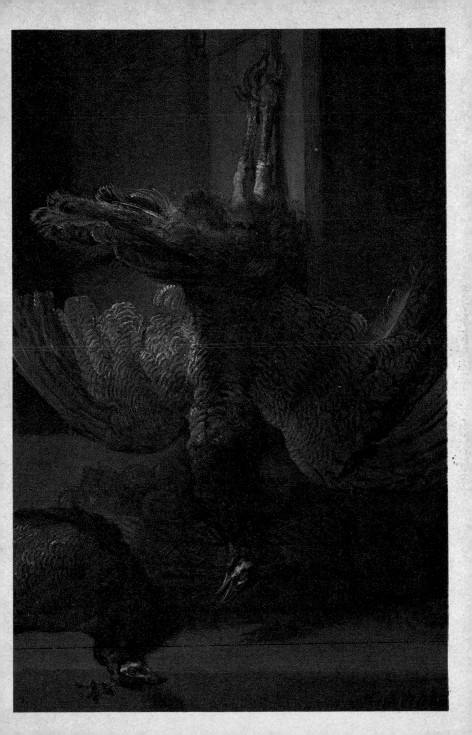

164 Man in Oriental Costume
Oil on canvas/98 × 74/*c*.1635
Washington DC, National
Gallery of Art

165 The Diplomat Anthonis Coopal
Oil on panel/83 × 67/s.d.1635
Greenwich, Connecticut,
Neumann de Vegvar
Collection

166 Saskia in Fancy Costume
Oil on panel/98 × 70/s.d.163(5 or 8)
Switzerland, Private
Collection

167 A Seventy-year-old Woman seated in an armchair
Oil on canvas/126 × 99/
s.d.163(5?)
New York, Metropolitan
Museum of Art

168 Tobias healing his father's blindness
Oil on panel/47.2 × 38.8/
s.d.1636
Stuttgart, Staatsgalerie

169 The Blinding of Samson by the Philistines
Oil on canvas/236 × 302/
s.d.1636
Frankfurt, Städelsches
Kunstinstitut

170 The Ascension of Christ
Oil on canvas/92.7 × 68.3/
s.d.1636
Munich, Alte Pinakothek

171 Self-Portrait with Saskia (The Prodigal Son in a Tavern)
Oil on canvas/161 × 131/s./
c.1636
Dresden, Gemäldegalerie

172 Self-Portrait
Oil on panel/62.5 × 47/s./
c.1636–7
The Hague, Mauritshuis

173 The Standard Bearer
Oil on canvas/125 × 105/
s.d.1636
Paris, Collection of Baron
Rothschild

165

166

164

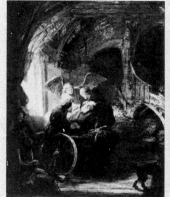
168

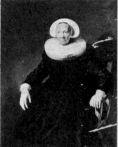
167

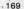
169

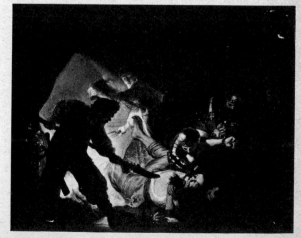

The Entombment (No. 194)
After years of delay the ENTOMBMENT *and the* RESURRECTION *were finally presented to Prince Frederik Henry in 1639. Although the Court's taste had changed and the cool classicism of Honthorst was very much in fashion in The Hague, Rembrandt was asked to paint two more pictures for the series some years later (*THE ADORATION OF THE SHEPHERDS *of 1646 and a now-lost* CIRCUMCISION*). These were, however, the last commission he received from the Orange Court.*

174 Woman of the Raman Family
Oil on panel/68.5 × 53.5/
s.d.1636
Though apparently dated two
years later, the picture is a
pendant to No. 144.
Rossie Priory, Perthshire,
Collection of Lord Kinnaird

175 Young Man with a Gold Chain
Oil on panel/57.5 × 44/
c.1636–7
São Paulo, Brazil, Museu de
Arte

176 Landscape with the Baptism of the Eunuch
Oil on canvas/85.5 × 108/
s.d.1636
Hanover, Niedersachsisches
Landesmuseum

177 Landscape with a Stone Bridge
Oil on panel/29.5 × 42.5/
c.1636
Amsterdam, Rijksmuseum

178 Stormy Landscape with an Arched Bridge
Oil on panel/28 × 40/c.1636–8
Berlin-Dahlem,
Gemäldegalerie

179 The Angel leaving Tobias and his Family
Oil on panel/68 × 52/s.d.1637
Paris, Louvre

180 The Parable of the Workers in the Vineyard
Oil on panel/31 × 42/s.d.1637
Leningrad, Hermitage

181 Susannah and the Elders
Oil on panel/47.5 × 39/
s.d.163(7?)
The Hague, Mauritshuis

182 St Francis at Prayer
Oil on panel/59 × 46.5/
s.d.1637
Columbus, Ohio, Gallery of
Fine Arts

183 Man in Polish Costume
Oil on·panel/97 × 66/s.d.1637
Washington DC, National
Gallery of Art

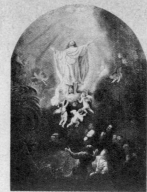

170

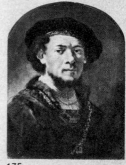

171

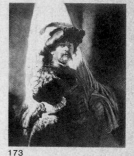

173

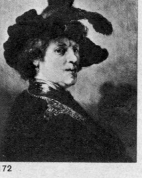

172

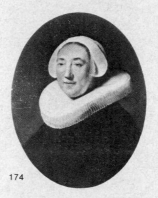

174

175

179

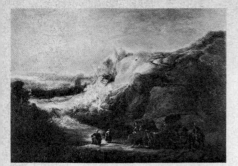

176

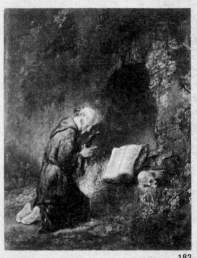

181

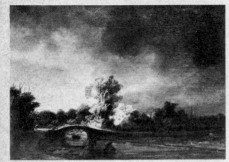

177

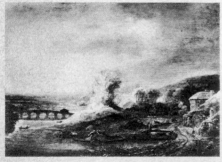

178

180

183

182

184

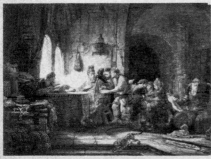

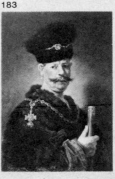

184 A Man seated in an armchair
Oil on canvas/134 × 103/
s.d.1637
Mertoun, Scotland,
Collection of the Duke of
Sutherland

185 The Risen Christ appearing to Mary Magdalen
Oil on panel/61 × 49.5/
s.d.1638
London, Buckingham Palace,
Royal Collection

186 Samson posing the riddle to the wedding guests
Oil on canvas/126 × 175/
s.d.1638
Dresden, Gemäldegalerie

187 Joseph relating his dreams
Grisaille – oil on paper
51 × 39/s.d.163(.)/c.1638
Amsterdam, Rijksmuseum

188 The Lamentation over the Dead Christ
Grisaille – oil on paper and
canvas stuck on panel/
32 × 26.5/c.1638
London, National Gallery

189 Child with Dead Peacocks
Oil on canvas/145 × 135.5/
c.1638
Amsterdam, Rijksmuseum

190 Landscape with an Obelisk
Oil on panel/55 × 71.5/c.1638
Boston, Isabella Stewart
Gardner Museum

Man standing in front of a doorway (No. 197)
This superb portrait dates from the end of the 1630s, a decade dominated by Rembrandt's portraiture of the fashionable society of Amsterdam. The full-length standing pose is unusual for Rembrandt and he has clearly been studying the portraits of Van Dyck, from which it is borrowed. The man has not been identified and the meaning of the glove apparently thrown down on the ground is not clear.

185

187

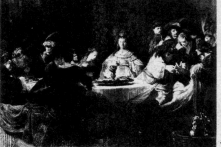

186

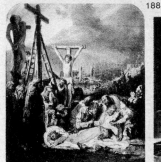

188

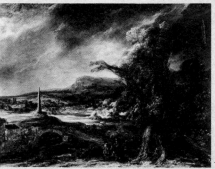

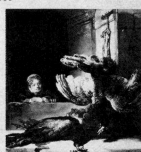

189

190

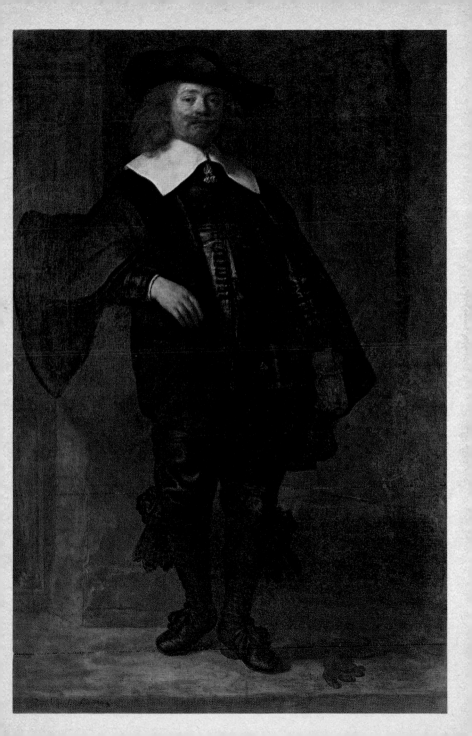

191 Landscape with the Good Samaritan
Oil on panel/46.5 × 66/
s.d.1638
Krakow, Czartoryski
Museum

192 Stormy Landscape
Oil on panel/52 × 72/s./c.1638
Brunswick, Herzog Anton
Ulrich-Museum

193 Woody Landscape with Ruins
Oil on panel/30 × 46/c.1638
Wassenaar, Holland, Private
Collection

194 The Entombment
Oil on canvas/92.5 × 68.9/
c.1639
Munich, Alte Pinakothek

195 The Resurrection
Oil on canvas transferred to
panel/91.9 × 67/s.d.163(9?)
Munich, Alte Pinakothek

**'Rembrandt's Mother'
(No. 198)**
*After Rembrandt's move to
Amsterdam his links with his
family in Leiden became less
and less close. It is Saskia's
relatives who are recorded
attending christenings, and
whose portraits Rembrandt
painted. This is the only
painting from the Amsterdam
years which is thought to have
Rembrandt's mother as a
model. It is not certain
whether it was meant to be a
portrait or whether she is the
model for a Biblical figure
such as the Prophetess Anna
(No. 52).*

191

192

193

194

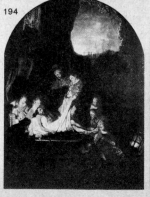

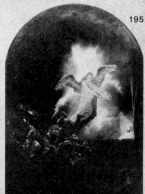

195

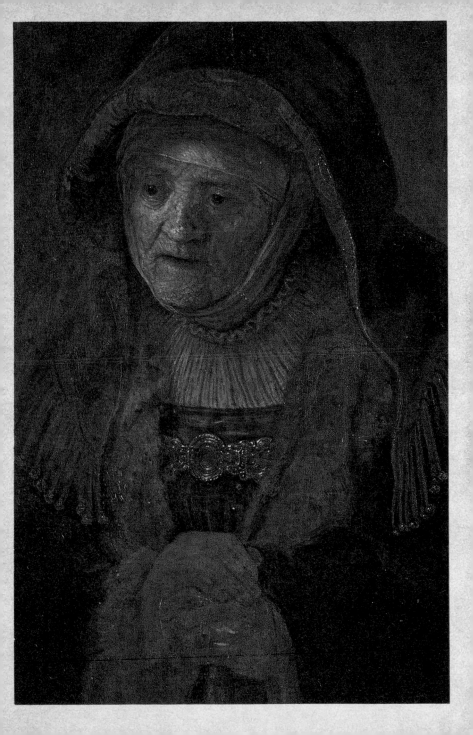

196 Self-Portrait with a Dead Bittern
Oil on panel/121 × 89/
s.d.1639
Dresden, Gemäldegalerie

197 Man standing in front of a doorway
Oil on canvas/200 × 124.2/
s.d.1639
Kassel, Gemäldegalerie

198 'Rembrandt's Mother'
Oil on panel/79.5 × 61.7/
s.d.1639
Vienna, Kunsthistorisches Museum

199 Alotte Adriaensdr.
Oil on panel/64.7 × 55.3/
s.d.1639
Rotterdam, Museum Boymans-van Beuningen (Willem van der Vorm Foundation)

200 Maria Trip, daughter of Alotte Adriaensdr.
Oil on panel/107 × 82/
s.d.1639
Amsterdam, Rijksmuseum (on loan from the van Weede Family Foundation)

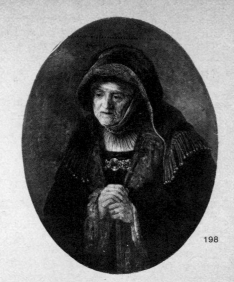

198

196

197

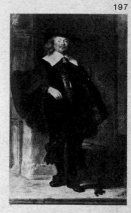

Portrait of Maria Trip, daughter of Alotte Adriaensdr. (No. 200)
Rembrandt had a number of contacts with the Trip family, enormously wealthy armaments dealers, during his life. He painted Alotte Adriaensdr. and her daughter Maria Tripp in 1639 and years later in 1661, when Alotte's brother-in-law, Jacob Trip, and his wife wanted portraits to present to their sons they turned again to the same painter, who had given satisfaction in this magnificent portrait.

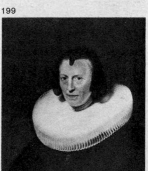

199

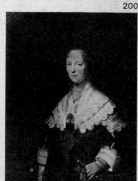

200

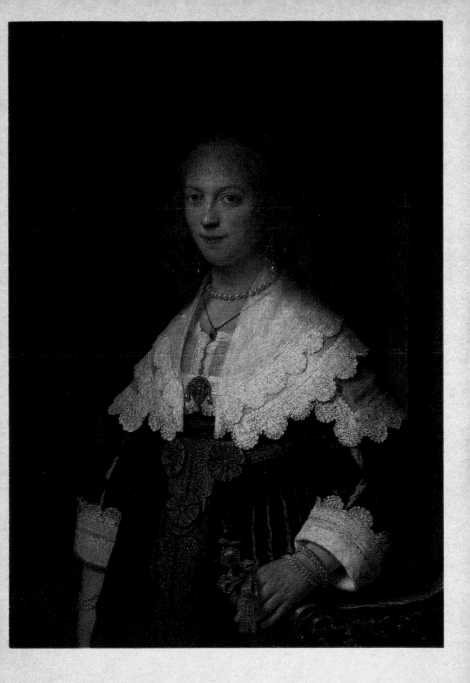

Photocredits
Bulloz: p. 15. Mauritshuis,
The Hague: pp. 17, 34, 35–6,
81. Bildarchiv Preussischer
Kulturbesitz: p. 31. Wallace
Collection, London: pp. 21,
71. Isabella Stewart Gardner
Museum, Boston: p. 47.
Gemäldegalerie, Dresden:
pp. 51, 75. Buckingham
Palace, Royal Collection,
London, by gracious
permission of H.M. the
Queen: pp. 52–3. Städelsches
Kunstinstitut, Frankfurt:
pp. 72–3. Gemäldegalerie,
Kassel: p. 91.
All other colour and black and
white pictures are from the
Rizzoli Photoarchive.

First published in the United States of America 1980
by Rizzoli International Publications, Inc.
712 Fifth Avenue, New York, New York 10019
Copyright © Rizzoli Editore 1979
This translation copyright © Granada Publishing 1980
Introduction copyright © Sir Ellis Waterhouse 1980
ISBN 0-8478-0268-X
LC 79-64899
Printed in Italy